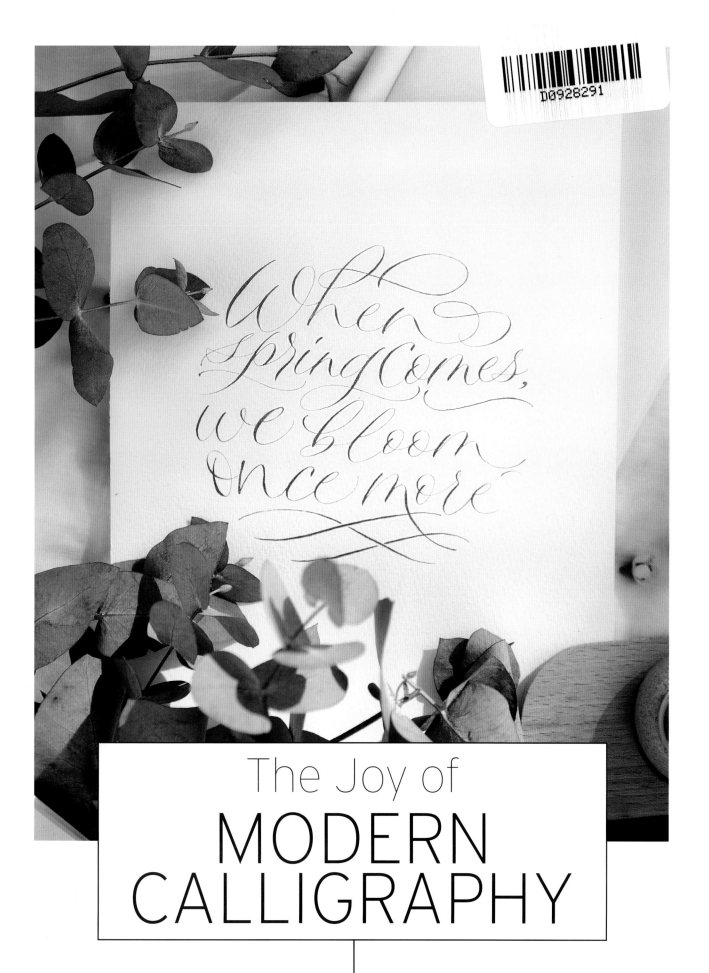

The Joy of
MODERN
CALLIGRAPHY

Dedication

To my Father, who has never failed to make everything beautiful in His time.
To my husband, Shaun, who always believed in me when I didn't.
This one's for you.

First published in 2021

Search Press Limited
Wellwood, North Farm Road,
Tunbridge Wells, Kent TN2 3DR

Text copyright © Joyce Lee 2021

Photographs by Rachel Loh

Photographs and design copyright © Search Press Ltd. 2021

ISBN: 978-1-78221-839-5
ebook ISBN: 978-1-80093-018-6

The Publishers and author can accept no responsibility for any consequences arising from the information, advice or instructions given in this publication.

Readers are permitted to reproduce any of the projects in this book for their personal use, or for the purposes of selling for charity, free of charge and without the prior permission of the Publishers. Any use of the items for commercial purposes is not permitted without the prior permission of the Publishers.

Suppliers
If you have difficulty in obtaining any of the materials and equipment mentioned in this book, then please visit the Search Press website for details of suppliers:
www.searchpress.com

You are invited to visit the author's website:
www.artsynibs.com

Acknowledgements

Foremost, I'd like to thank my calligraphy ladies, who have lovingly journeyed with me through my calligraphy wilderness. Your presence and input have made it possible for me to put together this comprehensive manual.

Thank you Bri and Gill for our frequent calligraphy discussions (but mostly about striking a balance between work and life). Your words have challenged and comforted me in this process of formulating my thoughts.

All the way in the suburbs of Manchester, I want to thank Tori for being one of my biggest cheerleaders, despite our physical distance. Your poetic words have always touched me and I'm glad some are featured here.

To my fellow colleagues and extremely talented calligraphers, thank you for contributing your amazing art pieces: Huy Hoang Dao, Leanda Xavian, Rosana Fulford, Jason Peng, Corinna Tai and Jessy Lim. It is my honour to use your work as references to showcase the wonderful world of calligraphy.

I also want to thank the family at Manuscript Pen Company for supporting me with the calligraphy supplies in this book. Our collaboration began back in 2015, and I'm looking forward to many more years of working together.

To Rachel Loh, who brought my works to life, thank you for being the creative soul you are and styling the beautiful images we enjoy in this book. The photo shoot wouldn't have gone so seamlessly without Regina, our hawk-eyed project manager for the day. I'm ever grateful for your commitment to this project.

Segey and Kate of CreativeInkHolders, your thoughtfully designed calligraphy accessories (the ink wells, nib caps and nib holders) have added great depth to the aesthetics of this book. Thank you for agreeing to this cross-continent collaboration.

Last but not least, a massive thanks to Lyndsey Dodd, Katie French and the entire team who worked on this book. I can't say enough 'thank yous' for putting this book together while working with my hectic schedule.

The Joy of
MODERN CALLIGRAPHY

A guide to the art of beautiful writing

Joyce Lee

SEARCH PRESS

CONTENTS

How to use this book

I appreciate that learning a new skill is exciting and you are probably desperate to get started straight away. However, I want you to know that practising calligraphy is more than just writing. It is also a lifestyle. The first few chapters will prepare you mentally on what to expect, walking you through some common challenges that may crop up along the way.

While there isn't a fixed set of rules for modern calligraphy, in 'What is Modern Calligraphy?' I put a strong emphasis on learning at least the basic rules from traditional scripts. 'Tools & Materials' teaches you how to pick the right tools as well as how to care for them. 'Theories & Techniques' gives you comprehensive instructions on how to use the pointed (dip) pen. The 'Projects' section suggests eight simple tasks that you can undertake on your own, to put your new skills into practice. Finally, I have included a FAQs section at the end, to help you troubleshoot.

The Joy of Modern Calligraphy is intended to be read chronologically. However, I am mindful that time may not always be on our side, so if you find yourself short on time, I would recommend diving straight into 'Calligra-Life Lessons'. These lessons are useful reminders that serve as pit stops for a quick check of our posture or tension halfway through an exercise.

PRACTICE SHEETS

In the envelope on the inside front cover of the folder, you will find 20 loose practice sheets that I've created for you. Each one has a number and a title and is referenced throughout the book wherever it is used. They correspond to exercises in the 'Theories & Techniques' section on pages 44–91:

1: Drawing your own gridlines
2: Basic strokes
3: Basic strokes continued
4: The oval group: a, c, o and e
5: The ascender group: b, h, k, l and d
6: The descender group: j, g, y and z
7: The repetition group: i, u, v, w, n and m
8: The exception group: f, p, q, r, s, x and t
9: A, C and E
10: B, D, P and R

11: H, K, L and Z
12: T, I, O and Q
13: J, G, F and S
14: U, V, W, X, Y, M and N
15: Words
16: Phrases
17: Proportion 1:1:1
18: Proportion 2:1:2
19: Proportion 3:2:3
20: The Artsynibs grid

I have included a sheet with just gridlines to save you having to draw out the lines for each exercise (Practice sheet 20).

You can write directly onto the sheets. However, I recommend photocopying them or overlaying a piece of tracing paper so you can use them to practise as many times as you like. Before reproducing them, please turn to page 40 to find out which practice paper is best to use for calligraphy. Extra copies of the practice sheets are available to download from www.bookmarkedhub.com.

INTRODUCTION

My modern calligraphy journey

THE FIRST ENCOUNTER

I have always had a strong affinity with pen and ink. Back in school, I used to hand-letter on my notes. I didn't know what hand-lettering was then. It was simply pretty bubbly writing that mimicked the fonts used in word processing software.

My husband is an avid fountain pen collector. Although attracted to these exquisite writing tools like a magpie to shiny things, I was initially nervous about trying out his delicate vintage fountain pens.

Encouraged by my husband's enthusiasm and how his eyes lit up as he shared his newfound hobby with me, I gave it a go. The nib flexed like butter and I discovered that I could create old-fashioned cursive writing simply by varying the pressure I exerted on the pen. I found the movement of writing in cursive enchanting, and it opened my eyes to how people used to correspond with each other before modern-day pens were commonplace.

Among my husband's fountain pens was a dip pen and a pointed nib. I was hooked after writing with a nib for the first time, back in 2012. The rhythmic strokes of writing with a dip pen drew me in, and I liked it as a more economical and durable alternative to a fountain pen.

My first encounter with the dip pen led me to try out a series of tools and materials in order to find the perfect combination of paper, nib and ink that would allow me to write without inky issues. Once I settled on the ideal set of tools and materials that worked for me, I couldn't stop writing.

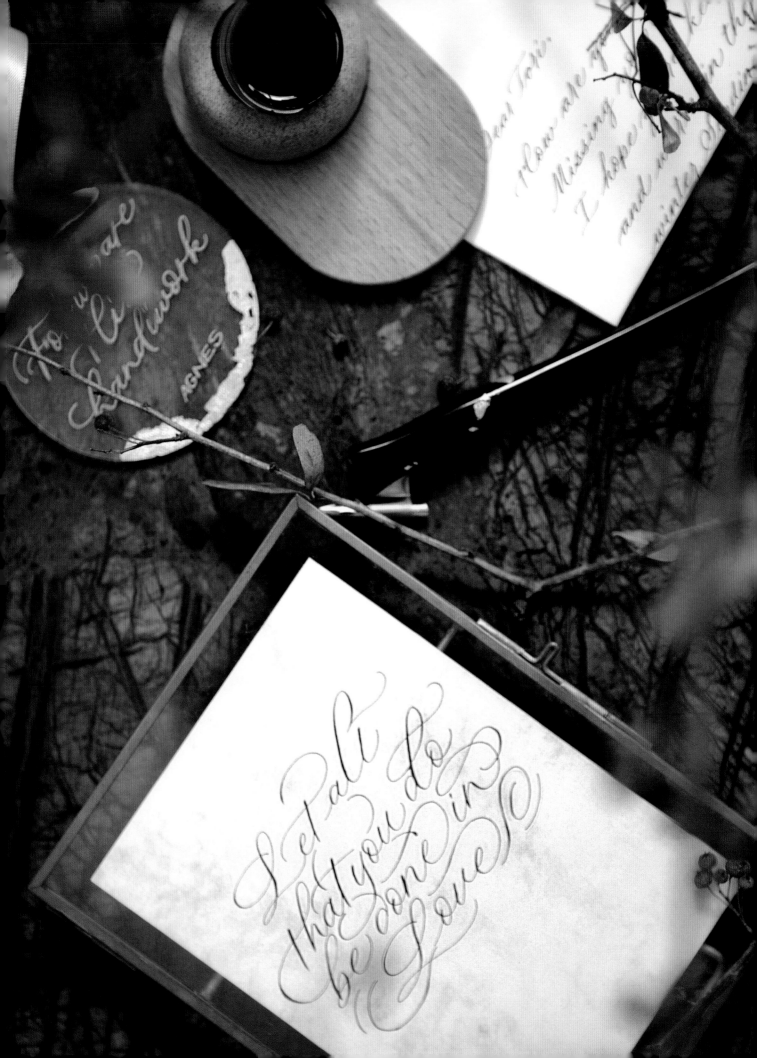

Why this book?

For a while, I have dreamed of writing a book that could help beginners make sense of the strict calligraphy techniques and create beautiful writing that appeals to our modern-day taste. I wanted to create a practical manual with relevant and in-depth information that every beginner needs, yet also sparing them from information overload by including stylish imagery.

At the same time, I wanted to share my personal calligraphy journey – both the ups and the downs. In being very authentic with this, I hope that this book can become both a learning resource and a cheerleader for you.

Calligraphy has seen me through a few seasons in life, but a huge aspect that brought me comfort was the community of other calligraphers. I have met kindred spirits from all walks of life, some of whom are now my inner circle of friends.

As I share with you the joy I've found in modern calligraphy, my hope is that you will discover your own quiet and solace on your journey.

I would encourage you to find a calligraphy support network online or in person that will be as meaningful to you as mine has been to me.

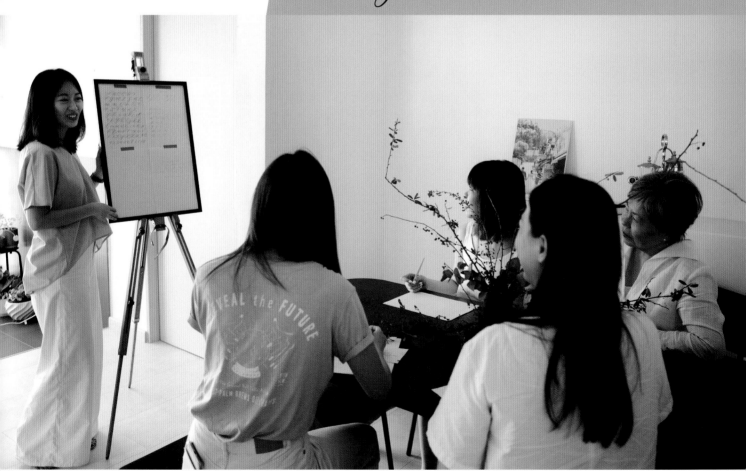

30-DAY CALLIGRAPHY CHALLENGE

Will you accept my 30-day calligraphy challenge? It is created with the intention of motivating you to practise daily. Think of it as an invisible accountability partner.

I understand that time may not be a luxury for most of us, so I've designed each challenge to be a quick ten-minute calligraphy 'workout'. You don't have to use the nib and ink, pencils work just as well. Regardless of your choice of tools, always try to begin each session with a one- to two-minute warm up (refer to page 56). As you progress through this calligraphy challenge, ask yourself these three questions:

· Are the straight lines parallel to each other?
· Are the curves turning at a consistent angle?
· Is the spacing between the lines consistent?

WHAT IS MODERN CALLIGRAPHY?

The term 'calligraphy' is defined as beautiful or ornamental writing.

Spanning both Eastern and Western cultures, calligraphy was employed to decorate religious or sacred texts. From the Chinese to the Arabs, the Roman to the British Empire, each civilization has developed its own set of characters and tools to turn their writings into exquisite pieces of art.

To categorize the broad umbrella of calligraphy into the labels 'traditional' and 'modern' doesn't do it justice. As with many other artforms, the popularity of calligraphy styles changes over time. However, for simplicity's sake, we'll refer to these two classifications: traditional and modern, where 'modern' refers to calligraphy that draws on both contemporary and time-honoured traditional resources.

While the term 'modern calligraphy' is constantly up for discussion and clearer definition, my personal interpretation of it is 'an individual's artistic take on what we've learnt from traditional scripts'.

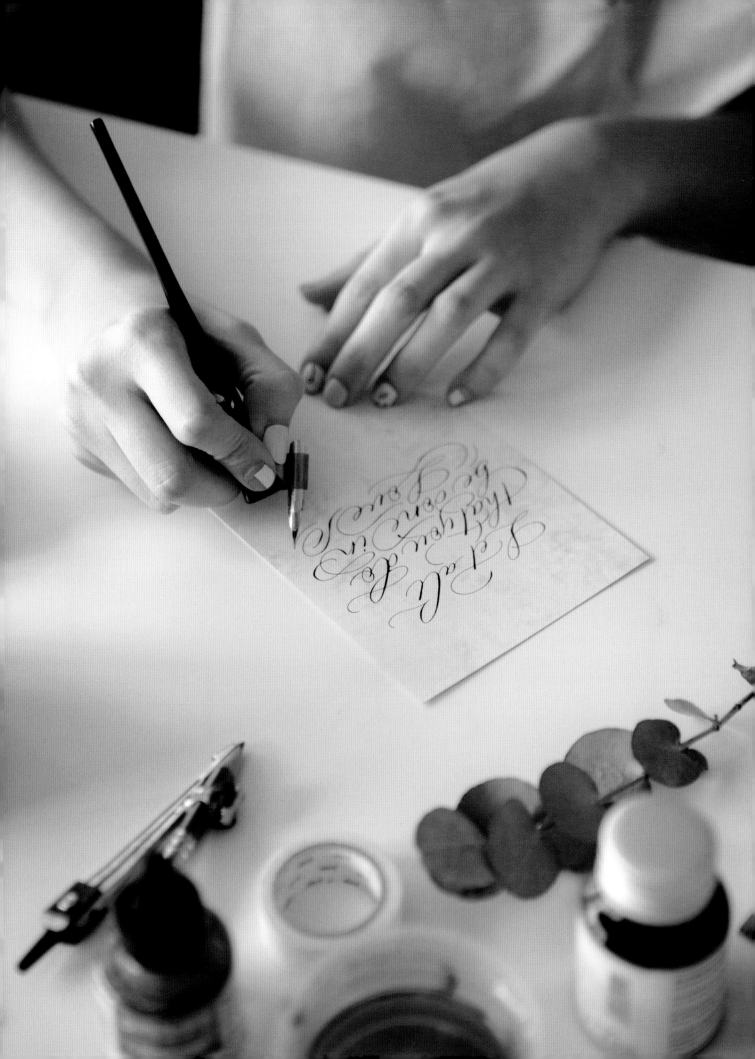

Shining the spotlight on Western calligraphy as derived from Latin, we find scripts like Roman square capitals, Uncial, Spencerian and English Roundhand. These are styles with specific systems of writing from the tools used to the way the pen is angled.

Having said this, it's worth mentioning that there are even more calligraphy scripts that date back well before these.

Fast forward to where we are now, in the digital age, we find ourselves in an era that celebrates individuality. This breeds a new generation of practitioners who now focus on designing variations of calligraphy styles based on traditional scripts.

We adapt what we know of traditional calligraphy to suit our modern-day lifestyle and tools – the use of rollerball pens, markers, the need to write faster and so forth.

Modern calligraphy is an individual's artistic take on what we've learnt from traditional scripts.

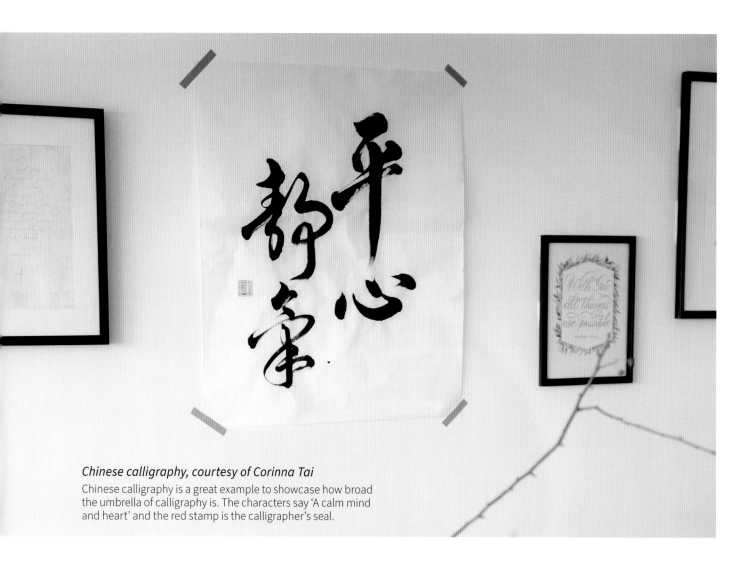

Chinese calligraphy, courtesy of Corinna Tai

Chinese calligraphy is a great example to showcase how broad the umbrella of calligraphy is. The characters say 'A calm mind and heart' and the red stamp is the calligrapher's seal.

Ornamental calligraphy, courtesy of Huy Hoang Dao
Apart from recording history and poetry, calligraphy is also employed for ornamental purposes.

▶▶▶▶▶▶ How are traditional and modern calligraphy different?

The focal point for most traditional scripts are the principles that govern the writing system. To learn these principles is to master these rules with the goal of recreating identical versions of it.

Traditional calligraphy also dictates the type of tools used. The broad edge nib for Gothic, the pointed nib for English Roundhand and the brush for Chinese calligraphy. However, with modern calligraphy, we are not bound by tools because realistically speaking, we have a lot more options available to us than the calligraphers before us.

Modern calligraphy values creativity over uniformity.
It operates with one fundamental rule:

consistency.

The Roman square capitals, courtesy of Leanda Xavian, The Fine Letter Co.

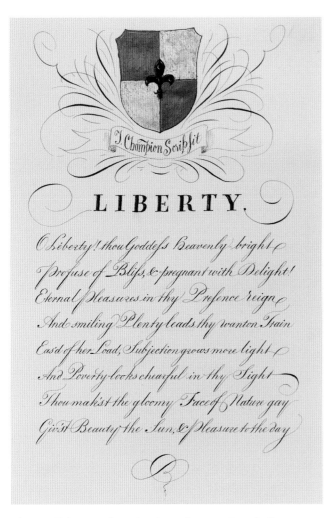

The English Roundhand script using a pointed nib, courtesy of Huy Hoang Dao. The poem is 'Liberty' by Joseph Champion

The Spencerian script, courtesy of Jessy Lim

The Gothic script using a broad edge nib, courtesy of Jason Peng, Jason Peng Studio

The Uncial script, courtesy of Rosana Ibarrola, Love Calligraphy

Why does everyone's modern calligraphy look different?

The 'imperfection' that modern calligraphy exudes makes it appear far more appealing than its more formal counterparts. It speaks a 'Be yourself' mantra that instantly makes this skill accessible to the vast majority.

The beauty of modern calligraphy is that your style becomes as unique as your character – almost like your own signature. This is why we find everyone's style different in one way or another. In traditional calligraphy, the opposite is true – it aimed for everyone's writing to look more uniform.

I'm a huge advocate of honing your own style once you have mastered the basics. The shapes that we draw will vary due to our natural muscle movements. Hence, I urge you to pay attention to how your body responds as you write.

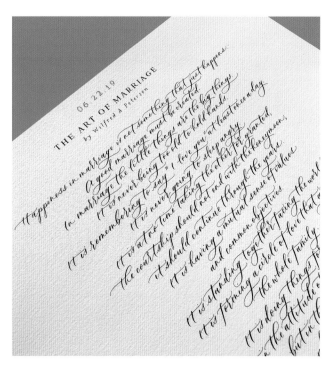

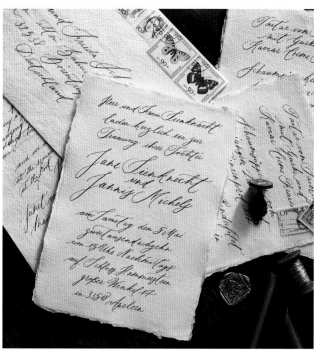

Modern calligraphy, courtesy of Brianne Knowles, Brown Fox Calligraphy. The poem is 'The Art of Marriage' by Wilferd A. Peterson

The sharp curves in Brianne's style give a lively and carefree note to the overall feel. The shapes of her letters resemble modern-day fonts, making the Brown Fox Calligraphy script more contemporary.

Modern calligraphy, courtesy of Nicole Sprekelmann, Nicnillas Ink

Nicole's calligraphy has longer strokes and gentler turns. This style has the same elegance you'll find in old European writings.

A song of ascents

Out of the depths I cry to you, Lord;
Lord, hear my voice.
Let your ears be attentive
to my cry for mercy.
If you, Lord, kept a record
Lord, who could stand?
But with you there is forgiveness,
so that we can, with reverence, serve you.
I wait for the Lord, my whole being waits,
and in his word I put my hope.
I wait for the Lord
more than watchmen wait for the morning
more than watchmen wait for the morning
Israel put your hope in the Lord,
for with the Lord is unfailing love
and with him is full redemption
He himself will redeem Israel
from all their sins

▶▶▶▶▶ Developing your own style

Developing a style is largely dependent on who you get your instructions or inspiration from. You can decide to master countless styles or go down the route of developing something that uniquely represents you.

Personally, I draw my inspiration from famous calligrapher P.R. Spencer (1800–1864), from whom we have the Spencerian script. I am also inspired by contemporary calligraphers Eleanor Winters and Rachel Yallop. You can see work inspired by their own on the opposite page.

At the time I wrote this book, I was battling anxiety after a series of health issues. To aggravate matters, the anxiety caused my right hand to tremble, threatening my livelihood of writing! Amidst the feelings of defeat, I considered the limits of my calligraphy ability. I knew I couldn't continue to write in my formal style with a trembling hand, and creating flourishes in my work became a massive challenge. For the sake of my wellbeing, I had to tweak things and evolve in order to survive and continue to thrive.

In this process of deriving your own style, it's imperative that you give yourself the freedom to evolve with the passing of time and seasons.

Your script morphs and develops as you go through life. Had I stuck firmly to my formal hand when my anxiety issues surfaced, I would have been utterly frustrated with myself and would not have been able to move on and mature in my style.

Your modern calligraphy style is derived through self-discovery.

Old Artsynibs style versus new Artsynibs style

Here you can see my old style (on the left). It has slimmer loops and narrower turns. My new style (on the right) now uses bigger loops, more uniformity and bolder flourishing.

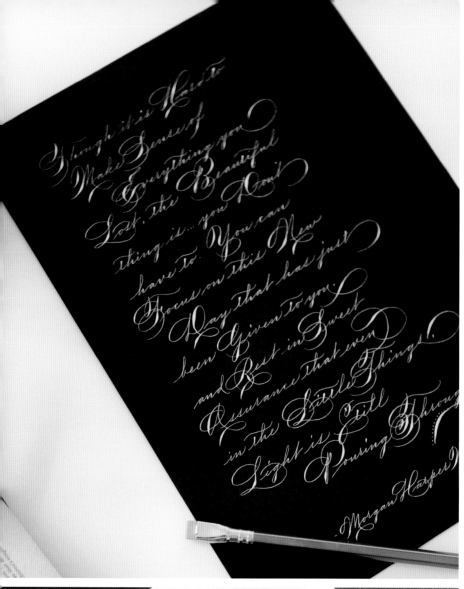

Example from Jessy Lim's calligraphy in Spencerian hand. Poem by Morgan Harper Nichols, used with kind permission

P.R. Spencer's slim and oval-like forms drew me in immediately. This script is very similar to a regular cursive handwriting, making it more accessible to me even without a pointed pen.

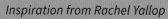

Inspiration from Rachel Yallop

Rachel Yallop's bold take on the traditional calligraphy script, commonly known as Copperplate, has always inspired me to break the mould once I've mastered the foundations. More than her writing, it's her ability to inject her creative personality into an otherwise uniform script that spurs me on to do the same.

▶▶▶▶▶ Modern calligraphy with a pointed pen

The pointed pen (or dip pen) is a sharp-ended nib that you attach to a nib holder. Traditionally, this was used for English Roundhand and Spencerian scripts. These modern calligraphy styles will see round or oval base shapes, as well as a variation of thick and thin lines.

On days when I need to be in full control, my choice of tool is the pointed pen. The brush pen becomes my preference when I'm feeling a little more adventurous and playful. But to keep things simple, I write mainly about how to use the pointed pen.

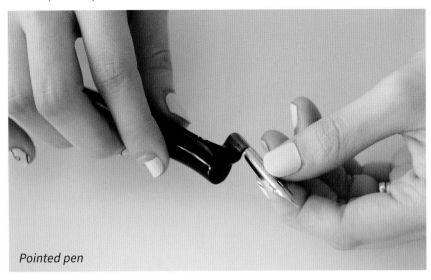

Pointed pen

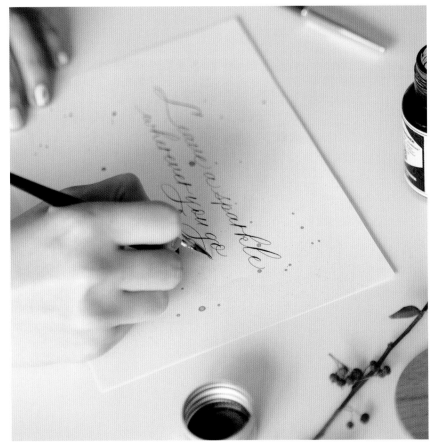

This image shows me writing in the Artsynibs style using a pointed pen and iron gall ink – a rare combination for me because iron gall ink is expensive where I live. However, this is a beautiful pairing as iron gall ink is a great ink to write with. If it's easily available to you, I highly recommend it. For more on this ink, see page 38.

Modern calligraphy with other tools

The other commonly used tools for modern calligraphy are the brush pen and markers.

While the tools differ, the fundamental rules of creating the letterforms are largely similar. These days, we have the luxury of a wide range of brush pens to choose from.

What works best for me, is the Pentel Touch brush pen. It has a flexible and small tip that is stiff enough to control, producing crisp thick and thin lines. This allows for a fair bit of variation in your writing, given enough practice and a steady, disciplined hand.

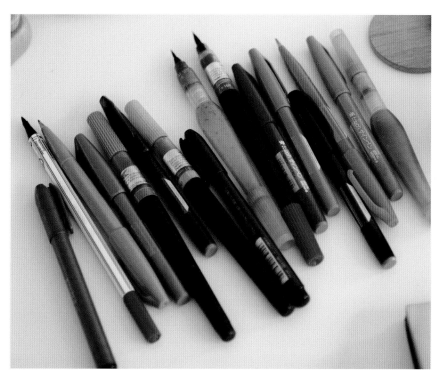

A selection of brush pens

There is a huge range of brush pens on the market, varying in the width, flexibility and material of the tip – and of course, the colour of the ink. Some are refillable. Water brushes – brush pens that come with an empty barrel that you can unscrew from the tip – are designed to be used with clean water for watercolour painting and other craft pursuits, but they also work well for calligraphy.

Calligraphy with a brush pen

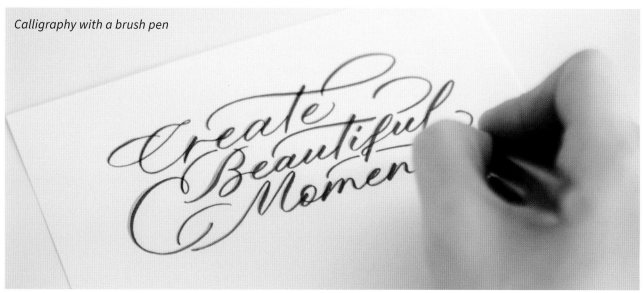

CALLIGRA-LIFE LESSONS

The modern calligraphy lifestyle hasn't changed much since the dawn of calligraphy. It's an art that requires patience, composure, and it can't be rushed. It requires characteristics that are counter-intuitive to our fast pace of life. When I moved to Singapore, the never-ending demands of a hectic city meant I had less time for leisurely calligraphy practice. However, it has also made me treasure the moments when I get to do just that.

Enjoy the little things.

Since taking up calligraphy, I have learnt much from the discipline. I intentinely make space for myself and routinely carve out time for self-care. I find myself breathing more deeply and moving unhurriedly.

As calligraphy with a pointed pen is quite a technical craft, slowing down gives you the time and space to work through the principles. While writing at this measured pace, you will realize how tiny movements can make a huge difference to your calligraphy.

Before we make a start on the calligraphy itself, there are a few lessons I'd like to share with you. These are things that have affected the way I see my journey with the pen and ink.

Don't forget to breathe

The first calligra-life lesson is simply this: remember to breathe!
When you are a beginner, it is normal to feel overwhelmed by the number of considerations that the practice requires. While trying to remember your letterforms, maintain the correct angles, and keep your strokes consistent, you have probably been holding your breath subconsciously the whole time. It's not surprising to find yourself doing this when you are concentrating so hard on everything else. In fact, in my years of teaching calligraphy, I have found that holding your breath is almost a quintessential part of the modern calligraphy experience.

What helps me remember to breathe is exhaling while executing a challenging stroke. I have also discovered that chatting as you practise is great because you need to breathe when you speak!

Remember: Breathing relaxes you and it aids with easing the shakiness.

Ask yourself these questions:

- Am I remembering to breathe?
- Is my hand gripping my pen too tightly?
- Is my other hand gripping the table?
- Is there any tension in my legs or shoulders?

Watch the tension

The second calligra-life lesson is linked to the first: remember to relax!
It is very natural for your body to tense up early on in this learning process as you are concentrating so hard on the strokes and focusing on the page in front of you.

Relax your shoulders and allow them to sit comfortably. Try to spot where the ball of tension ends up every now and then. Has it now gone to your master hand and you're gripping on to your pen?

Or perhaps it's transferred to your other hand and you feel as though you're clawing on the table? If you are right-handed, the tension will normally end up in your left hand. It may not affect your writing, but your hand will ache terribly after clamping down on the table for hours.

Check if you're tilting your head one way or the other, because that will leave a painful strain on your neck. Pay attention to your legs – are you crossing your legs too tightly or pointing your toes too hard?

Remember, the ball of tension bounces around your body. It's worth learning to notice where it ends up so you can soothe it.

Posture, posture, posture

The third calligra-life lesson is this: correct your posture.

Another outcome of intense focus is leaning into the paper. The students I teach burst into giggles when they realize how instinctively the body moves closer to the paper as you start to write.

What often happens is you start writing with a perfect posture and, before you know it, you have hunched so far over your work it's as though you're examining the microscopic details of the fibres that make up the paper you are writing on.

Sitting too close to the paper limits your movement, and it leaves your back sore when you come out of this posture.

It has a visibly negative effect on the quality of your calligraphy, along with reducing your stamina for writing sessions due to the added muscle aches and cramps that it inevitably causes.

Every few minutes, remember to sit up, relax and consciously reassume the correct writing posture.

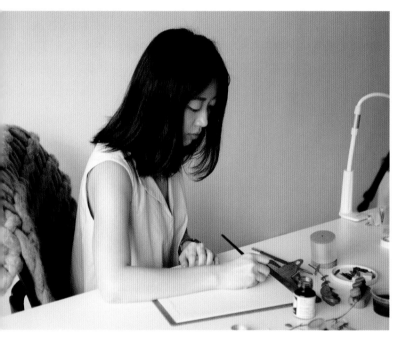

Good posture
My back is straight and my arm is relaxed with plenty of space to move. With my weight evenly distributed, my whole arm is free to move.

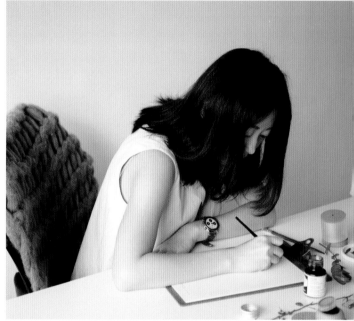

Bad posture
My shoulders are collapsed forward here and my face is much closer to the table.

Sit comfortably to write, sit comfortably to move.

Think first, write later

The fourth calligra-life lesson is: plan your work before you start.
It is always a good idea to create your writing in your mind before penning it down. Sketch out your artwork and take time to consider the flow of movement that your pen will take. Ask yourself some questions:

- Where will the thick lines go?
- Where are the turns?
- Where are the parts you can pause for a break?

You will often see videos of calligraphers who seem to be able to create beautiful, free-form calligraphy without planning or guides. That is indeed possible, but it's usually because the calligrapher is so experienced that they can visualize the framework for their calligraphy in their mind's eye.

When you're at the start of your calligraphy journey, it's best to rely on sketching out your artwork beforehand. As you practise and gain experience, you can certainly work towards the goal of being able to create wonderful writing without these preliminary sketches!

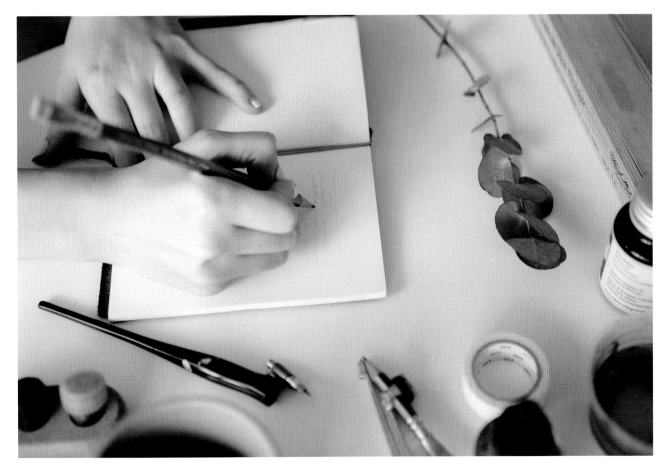

Gridlines
Using a pencil and a ruler, draw out simple gridlines where your calligraphy sketch can go. Pencil in your calligraphy and then go over it with the pointed pen and ink.

Decaffeinate

The fifth calligra-life lesson is: detox from caffeine.
As much as I love coffee to perk me up, caffeine also aggravates shaky hands. This makes your attempts to produce a clean straight line an uphill battle. The same applies to caffeinated teas, sodas and a multitude of other beverages.

Over the years, I've taught many students who struggled to control wriggly lines. Time and again, experience has shown me that caffeine was the culprit.

If you've consumed caffeine before your practice, pace yourself. Understand that the shakiness is partially a physical reaction to what's running through your veins at that moment. I acknowledge that some people drink six coffees a day and their bodies are well-accustomed to this. However, humour me and try a session of calligraphy once, immediately after drinking a coffee, and another time, without any caffeine in your system for at least three to four hours. Compare your work side by side and the results should speak for themselves.

Grab a pen and start writing

The sixth calligra-life lesson is: practise when you can.
I am often asked how much practice is required on a daily basis. Given our day-to-day commitments and busy lives, it's safe to say that sometimes even the thought of setting up your writing area, or finding a spot that's comfortable to write at, is enough to tire you out!

I can relate to that, as I went through a period when setting aside even half an hour for practice wasn't sustainable for me, so I adapted. I went back to using a fountain pen and paper for journalling and even writing notes. In doing this, I found myself observing my letterforms. Even though I was using a pen instead of a nib, I was deliberate about the shapes that I was making.

I started writing more and as I wrote I considered how I was holding my pen, I thought about my grip, my posture and my breathing. These are aspects of the learning journey that are equally as important as the writing itself.

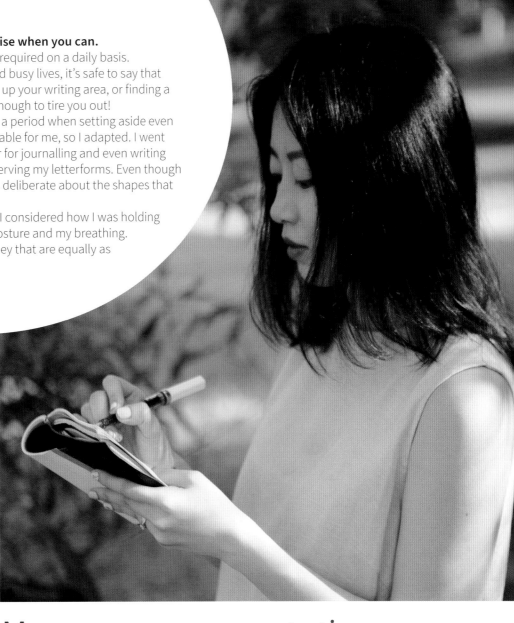

Manage your expectations

The final calligra-life lesson is: be kind to yourself.
Managing your own expectations is crucial for the journey ahead. Be careful not to assume that because your handwriting is neat it will be easier or faster for you to pick up calligraphy. I have met countless people who give up on their calligraphy practice out of sheer frustration, either with the lack of progress or the unchanging battles with the writing tool.

Additionally, in this age where we are absolutely inundated by social media, don't let your peers' beautiful writing send you down the rabbit hole of comparison. We need to recognize that we all move at different paces, but with time and effort we can expect to see improvement in our own work.

TOOLS & MATERIALS

Choosing from a myriad of pens, nibs and paper out there, I've selected
a smaller range of items that I use frequently. If you are just starting
out on your calligraphy journey and can't decide which tools to try,
I would recommend the Manuscript modern calligraphy set. It is a good
starter kit to invest in and you will need it for the exercises that follow.
We've looked at the basics of pointed pens and brush pens on pages 20–21;
this part of the book looks at the supporting tools and the all-important
writing surface.

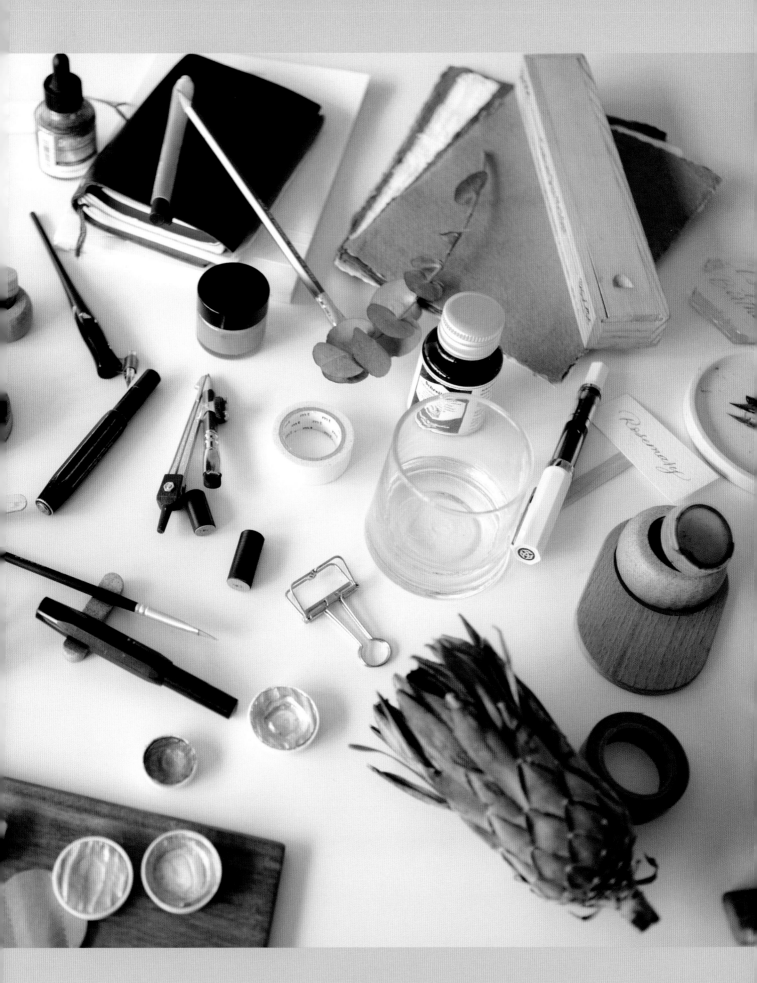

⬤⬤⬤ Nibs

NIB ANATOMY

Before we begin writing, it's worth familiarizing yourself with the anatomy of the pointed nib. Starting from the top, the sharpest point of the nib is called the tip. The line that cuts down the tip splits it into two parts known as tines.

Below the vent is usually the brand and model of the nib. Moving further down, you will find the base of the nib.

I always advise people to handle the nib by the base instead of the tip. When we touch the tip, we transfer the natural oil from our fingers onto it. This causes ink to roll off the nib when it should really be holding it instead. This oil also accelerates the decay and rust of nibs.

When you have to handle the nib by the tip, grab a piece of paper towel or cloth and use that as a barrier. This also prevents you from getting pricked by the sharp tip (speaking from experience here!).

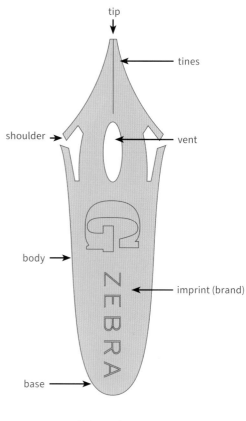

Nib anatomy

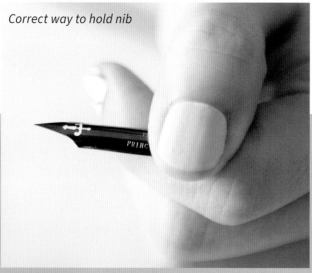

Correct way to hold nib

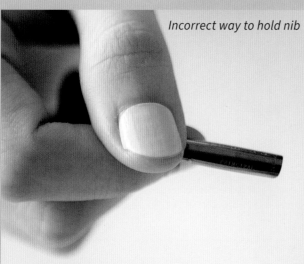

Incorrect way to hold nib

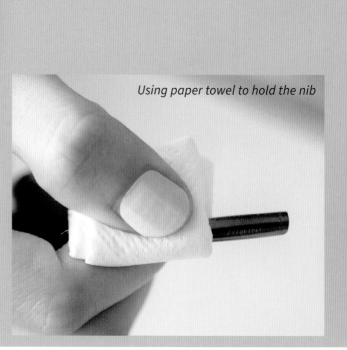

Using paper towel to hold the nib

Hold the smooth end of the nib and rest the tip on the table. As you exert pressure on the nib, you'll notice the tines separating. This movement of the tines will create the thick and thin lines you see in pointed pen calligraphy. Very often, this variation is what creates the 'wow' effect with people, because you can never achieve this naturally with a ballpoint or rollerball pen (or most writing tools, in fact).

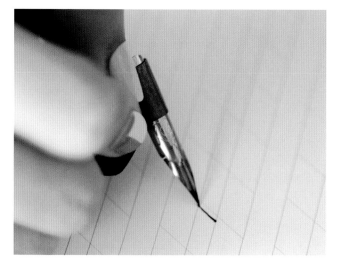

Tines unspread

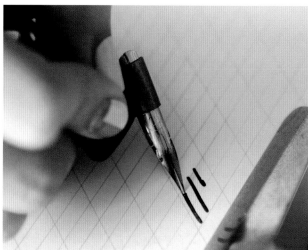

The wow factor!

As you follow the tines downwards, you'll notice a hole in the middle of the nib. This is the vent. The vent is great for two things:

1 It helps you gauge how deep to dip the nib into the ink. Once the vent is submerged in the ink, you are ready to start. There is no need to dip the entire nib in and risk staining your nib holder.
2 It's an effective indicator that you're holding the pen correctly. When writing, the vent should be facing upwards (towards the ceiling) and forward. This ensures that the tines split evenly when pressure is applied and prolongs the lifespan of your nib.

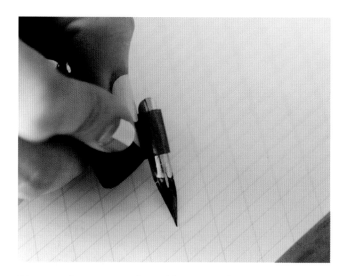

The vent faces upwards and forward when writing

How far to dip the nib into the ink

NIB TYPES

With a myriad of nibs available on the market, one of the most common questions I am asked is – *What is a good nib for a beginner?* This assumes that everyone holds the pen or writes the same way, but that's definitely not the case. The simple answer is a 'G' nib. 'G' stands for 'general' and many brands manufacture this model of nib.

It is worth understanding the types of pointed nibs available to you on the market.

Hard nibs are made of stainless steel and are stiffer. Their hardy nature makes them great when you're starting out, especially the 'G' nibs. Some examples are Nikko G or Zebra G. Hard nibs require more effort to flex and this may not bode well with individuals who are naturally light-handed.

Soft nibs are the copper ones that feel more flexible. They flex with little to no pressure, making them a great option for light-handed writers. Some examples of soft nibs are the Leonardt 40 and Leonardt Principal nib.

Many new calligraphy explorers tend to want to go straight for the nib with the biggest amount of flex, in order to replicate that 'wow' experience. However, this can sometimes be a double-edged sword, as soft nibs can be tough for a heavy-handed user at first.

Ideally, it's best to purchase a hard and a soft nib to kick-start your journey. Observe the kind of writer you are: are you light-handed or heavy-handed? This should influence your choice of nib, and help with troubleshooting.

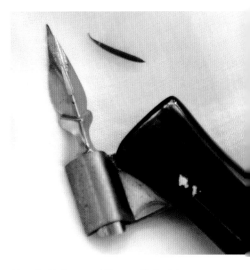

Hard nib in an oblique nib holder

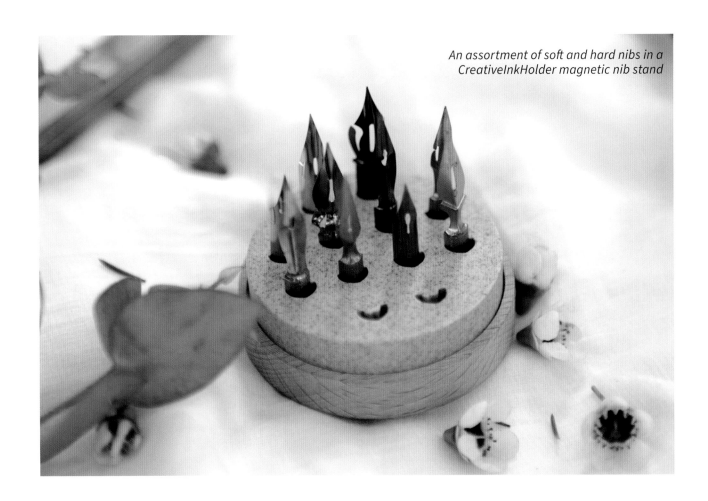

*An assortment of soft and hard nibs in a
CreativeInkHolder magnetic nib stand*

NIB PREPARATION

Most nibs come with a protective layer of lubricant that needs to be removed. As mentioned before, an oily nib doesn't hold ink well.

There are many ways to prepare your nib for writing, but here are three different methods I use:

1 Wipe it thoroughly with nail polish remover.
2 Pass the top and bottom of the tip through a quick flame (three to four seconds each side).
3 When preparing multiple nibs, stick them into a (raw) potato for a few minutes then rinse them with water.

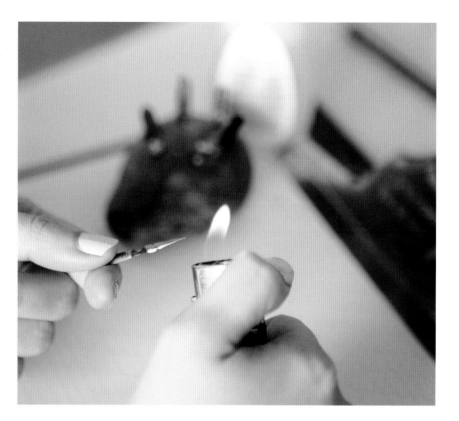

Nib holders

The holder you attach the nib to comes in two orientations: straight and oblique.

Whether you are left- or right-handed, the straight nib holder is a safe choice for a beginner. Having said this, there are also world-renowned calligraphers who subscribe to the straight holder. One real advantage of it is that it prevents you carrying too much tension in your shoulders, compared to when using the oblique holder.

Currently, I use the oblique holder more frequently than the straight one because it helps me keep a consistent slant that my personal writing style requires.

When buying an oblique holder, make sure you get one fitted for your dominant hand.

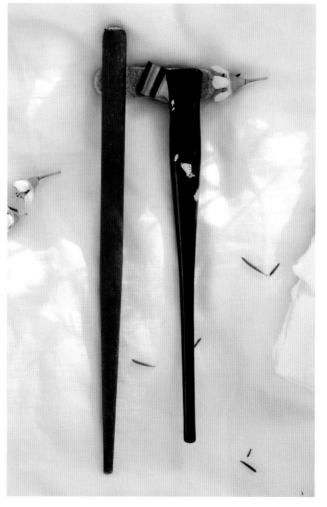

Nib holders: Straight (left)*, right-handed oblique* (right)
The oblique holder features a flange that sticks out of the side. When assembled, it points the nib at a specific angle. This helps the user to achieve a consistant slant when the pen is held correctly.
The flange of the right-handed oblique holder sticks out of the left side of the pen and the opposite is true for the left-handed oblique holder (not in this image).

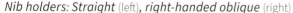

Ink

One of the first places people tend to look when shopping for ink is the fountain pen section. However, most fountain pen ink tends to be rather runny, which rules it out for calligraphy. For ink to work well with your pointed nib, it shouldn't be too oily or watery.

Instead, here are some great options that go hand in hand with the pointed nib:

WALNUT INK

My go-to option is walnut ink, made from walnut husks and then processed into crystal form.

You mix the walnut crystals with warm water or you could simply buy them pre-mixed already. What I love about walnut ink is the ability it gives to adjust the shade of brown according to my whims and fancies.

A word of warning: keep this ink away from unvarnished wood or leather products, because staining is irreversible.

Ink bottle holders

There's nothing better to pair beautiful writing with than some thoughtfully designed calligraphy accessories by CreativeInkHolder.

The simple inkwell shown is one of my favourite ink bottle holders because it adds a quiet touch of colour to the regular black and white I tend to work with. It serves as a lovely contrast to the walnut ink it contains. Here, the wooden stand is a classy addition to the inkwell. It can also be used as a pen rest during your practice. Note also the walnut ink powder in this image.

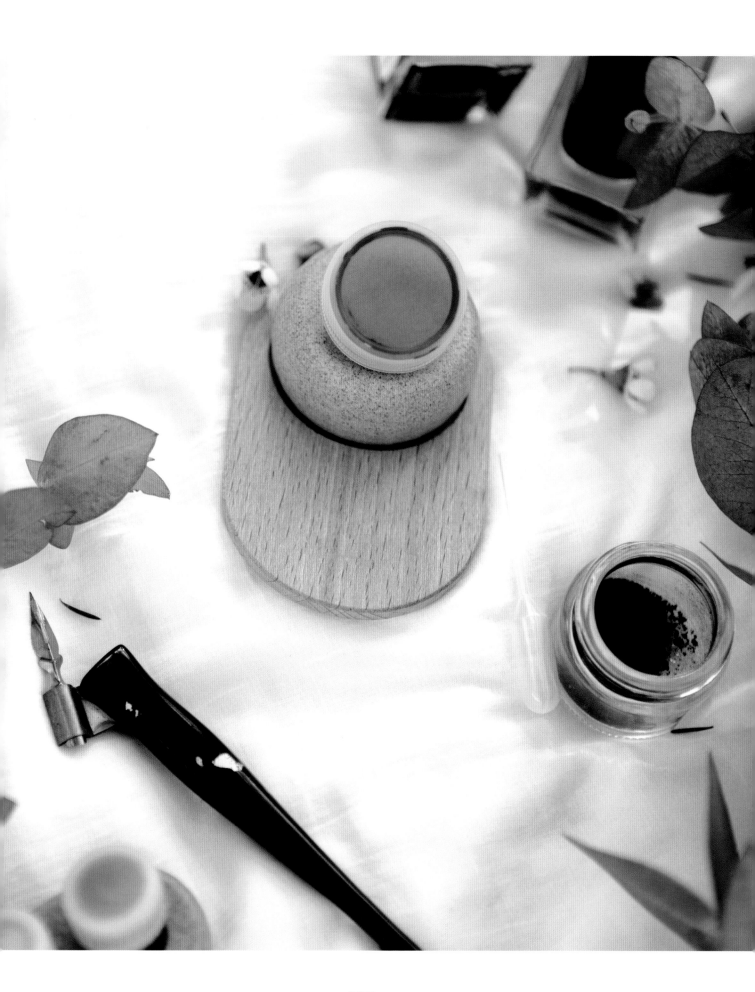

JAPANESE SUMI

Japanese *sumi* ink is another fantastic one to consider. It might need diluting with a little bit of water, to ease the ink flow.

Sumi ink tends to dry up rather quickly, especially when you're writing in the summer, or if you live in a tropical climate, so get in the habit of putting the cap back on.

I learnt this the hard way when my trusty sumi ink kept acting up after my relocation from the UK to Singapore. I realized that while I could leave it uncapped for hours at a time in the UK, that was a big no-no in the tropical climate of Singapore.

This alcohol-based ink can also make your nib too oily to continue holding any ink. The brands that dry out faster may coat your nib with layers of black ink, disrupting the ink flow. If that happens, wash the ink off the nib and wipe it dry.

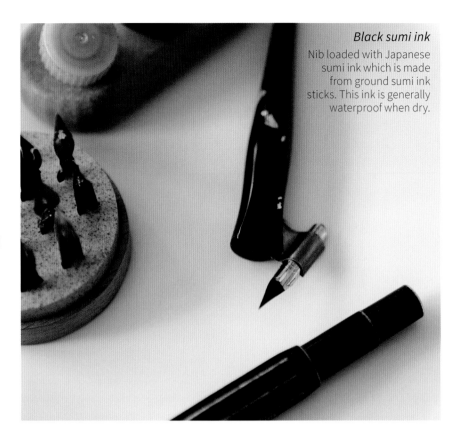

Black sumi ink
Nib loaded with Japanese sumi ink which is made from ground sumi ink sticks. This ink is generally waterproof when dry.

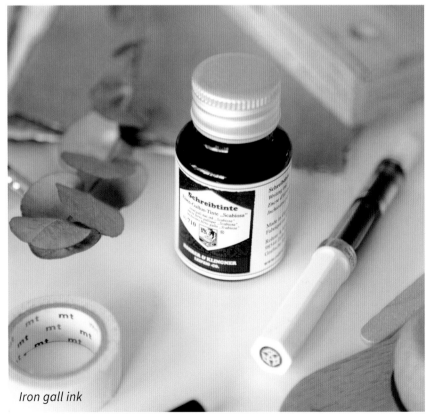

Iron gall ink

IRON GALL INK

Iron gall ink is a traditional option for Western calligraphy. Made from oak gall, iron salts and gum arabic, its viscosity makes iron gall ink an 'obedient' ink to handle.

When we are practising calligraphy, we tend to use up a lot of ink, so we usually gravitate towards products that we can get hold of easily. Living in South East Asia, Japanese sumi ink is more readily available to me than iron gall ink.

However, if you have easy and affordable access to iron gall ink, feel free to experiment with this waterproof and lightfast ink to see if it's a suitable fit for you!

WATERCOLOUR AND GOUACHE

Using watercolour and gouache paint is the perfect way to introduce colour into your calligraphy.

Watercolour in pans, tubes and concentrates are user-friendly for pointed nibs. To pick up and apply ink from the pan to the nib, all you need is a brush. Simply dip your brush into your watercolour or gouache, and 'paint' your nib with the colour before writing!

To prepare ink from gouache, you simply mix your colour of choice with water and add some gum arabic. Gum arabic is a solution that allows you to control the viscosity of your ink. Add a few drops at a time, and test, until the consistency is what you are after.

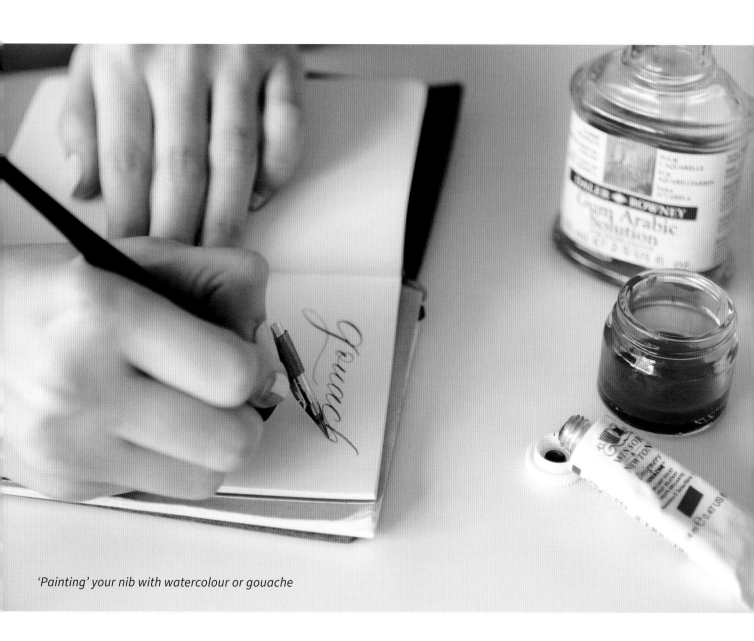

'Painting' your nib with watercolour or gouache

Paper

Writing with a pointed nib essentially means carving your words onto the paper. The sharp tip of the nib scratches off the top layer of your canvas, leaving a trail of ink that will eventually form your masterpiece.

It is important, therefore, that your paper is strong enough to withstand this 'destruction' to its structure, while maintaining the integrity of the ink.

When I first began my calligraphy journey, I bought notebooks and writing pads to practise in, only to find my ink bleeding through the paper. 'Bleeding' is what happens when the ink seeps all the way through to the other side of the paper, perhaps even staining the page behind. While it would be ideal to find paper that holds ink well, sometimes we may have to settle for paper that 'ghosts' a little.

Ghosting happens when the ink leaves a slight shadow on the other side of the paper. It's not wet enough to leak all the way through to the other side, but wet enough to confuse you as you attempt to read your indistinct, 'shadowy' writing.

One thing about paper I wish I had known from the start is that *it's not the thickness that is important, but the material and smoothness.*

Paper made from cotton will generally handle the pointed nib better and smoother paper can actually prolong the lifespan of your nib. Some examples of smooth paper are vellum paper, laser copy paper, tracing paper and layout paper.

Having said this, I'm not ruling out the use of card stock, watercolour paper or handmade cotton paper. They are all excellent options that produce elegant artwork and are generally bleed-proof.

However, take care when writing on textured paper in case you find your nib 'clicking' more often than usual. This clicking sound occurs when the tines are forced into an awkward angle. To reduce this, select a hard nib and slow down your writing speed when working on textured surfaces.

As we dive deeper into the world of calligraphy, don't be surprised if you find yourself becoming something of a paper connoisseur. When I first started out, I didn't know a single paper brand, type or material. Now, I can tell the difference between French paper, Japanese paper and English paper, not to mention the different methods they use to create the material.

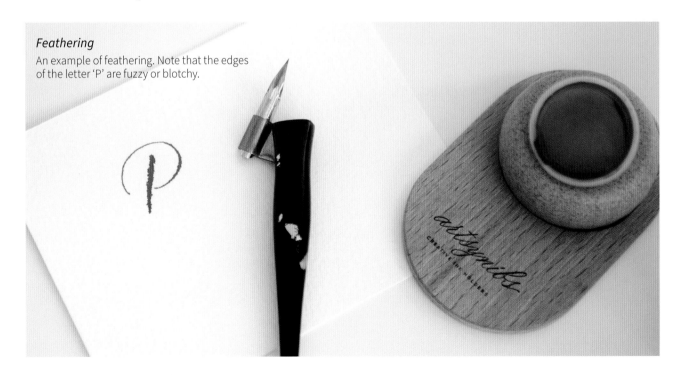

Feathering
An example of feathering. Note that the edges of the letter 'P' are fuzzy or blotchy.

Did you know that certain types of paper have different coatings on them, affecting the shade, sheen and dry-time of your ink?

Tomoe River paper
This paper is known to be extremely thin, smooth and holds ink well.

PRACTICE PAPER

Since you will undoubtedly go through a fair bit of paper when practising, laser copy paper is your best option. While some inkjet papers work, they are usually rougher. Some brands that I turn to are Clairefontaine, Hewlett-Packard, Conqueror and PaperOne. I recommend them because they are easily available and very affordable.

ARTWORK PAPER

My go-to paper for artwork is handmade cotton paper or watercolour paper, because I prefer to work with textured surfaces. However, if you feel more confident working on a smoother surface, hot-pressed watercolour paper is less grainy.

Another advantage of the handmade paper I use is that it is made from recycled cotton rags, so it is eco-friendly and sustainable.

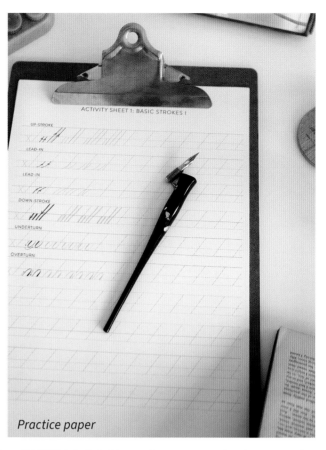

Practice paper

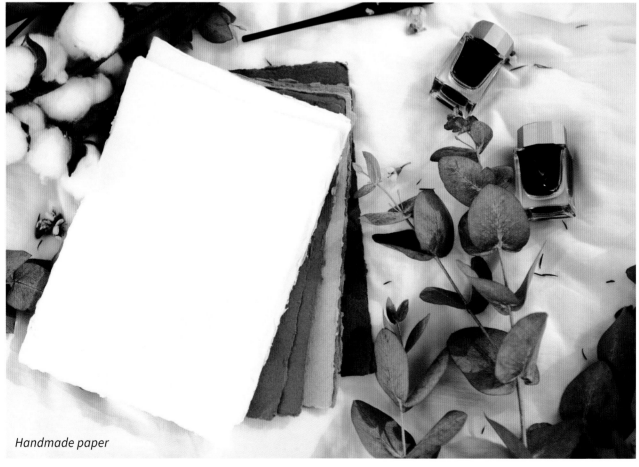

Handmade paper

NOTEBOOKS AND NOTEPADS

Unfortunately, most notebooks on the market aren't designed with the nib and ink in mind. The paper in many will cause your ink to feather or even bleed through. I have a few trusted brands for writing pads or even a Bullet Journal. These are Rhodia, Leuchtturm, Clairefontaine, Muji and KOKUYO. I have found these brands the most reliable in preventing feathering or bleeding.

An assortment of my own notebooks and notepads

THEORIES & TECHNIQUES

Now that we have discussed the handful of materials we need, let's dive straight into some important underlying theory and then on to the techniques. You might be feeling impatient to get started on the writing itself, but bear with me because, as you will soon see, there is so much more to calligraphy than just handling the pen.

This section will walk you through the different parts of the letter, the proportions you need to consider, and how to break letters into into manageable strokes. I also discuss lowercase and uppercase letters, and I have grouped these into useful categories. Once you have brushed up on the base template – your first set of A–Z, you can experiment with different variations in style.

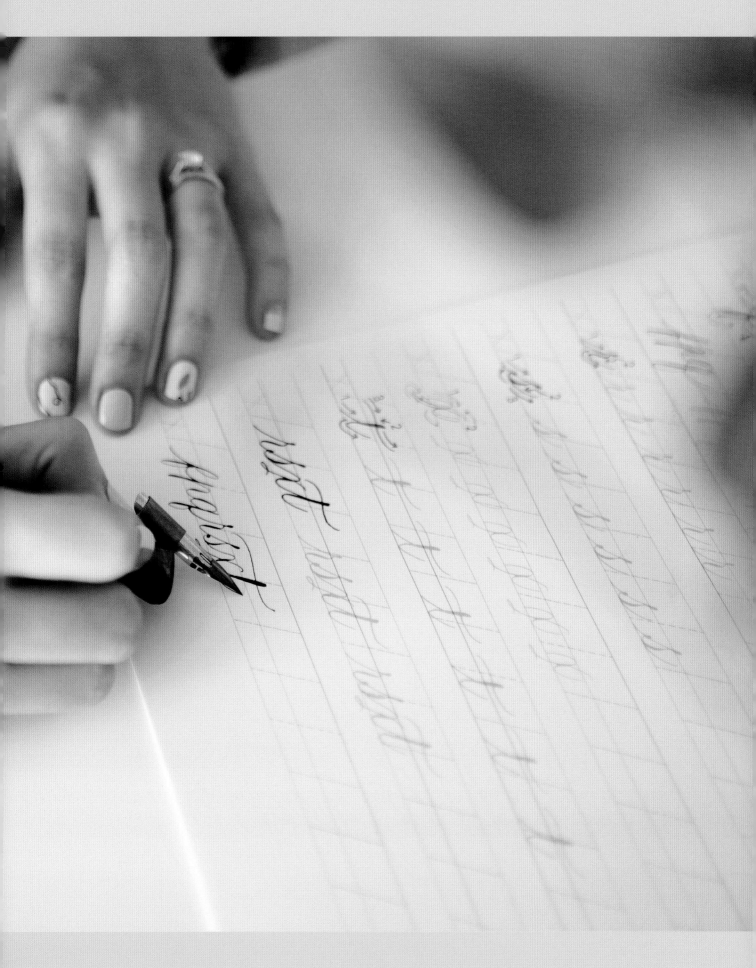

Lines and space

Before we dive into learning the basic strokes, it's important that we know the grid that we're working on. Here, we'll be exploring the different components that make up the grid as well as their function.

X-HEIGHT

The space that most lowercase letters exist in is known as the x-height. It is your main writing area. It is called 'x' because it's up to you to determine the exact measurement. Personally, I work with an x-height that ranges between 0.5cm (3/16in) and 0.8cm (5/16in). In practice, I wouldn't recommend anything bigger than 0.8cm (5/16in), because imagine how big the 'b' and 'g' will be if the x-height is as big as 1cm (3/8in).

 After some time of testing, I've found this range to be the most ideal measurement for me because it gives me the most comfortable range of movement. I'd highly encourage you to have a go and find out what works best for you.

ASCENDER LINE

The 'ascender' is the part of certain lowercase letters, such as 'b' or 'h', that extends above the body of the letter. The ascender line sits at the very top, where most ascending lines hit. In that space, you'll find ascender loops.

DESCENDER LINE

The 'descender' is the portion of a letter, such as 'j' or 'y', that extends below the body of the letter. Directly opposite the ascender line is the descender line. As its name suggests, this is where descending lines hit. Some of these will create descender loops.

BASELINE

Most letters perch on the baseline. The baseline marks the start of your x-height as well.

STEM

The stem is the main downstroke that runs from the ascender line to the baseline, or from the waistline down to the descender line. It's usually the only and longest straight downstroke in the letter.

'WAISTLINE'

Enclosing the upper limit of the x-height is this final line. It is commonly known as the waistline because if you refer to the illustration opposite, adding a line across the waist is the only way to divide the body into four equal parts. The same is true for dividing our grid into four.

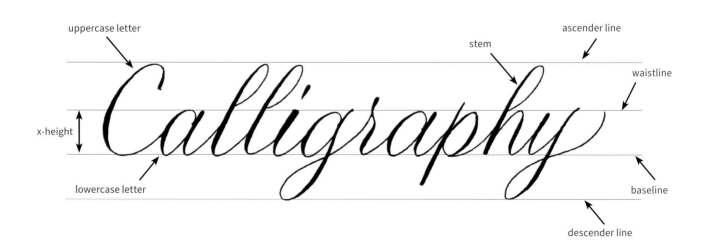

uppercase letter

stem

ascender line

waistline

x-height

lowercase letter

baseline

descender line

Proportions

To illustrate proportion, imagine dissecting your body into four equal parts.
The ascender line touches the top of your head; the descender line is where
your feet hit the floor; the baseline cuts through your knees; what is missing?
Looking at this illustration below, you'll find that the *waistline* is what's missing.
I use the human body as a reference here because our eyes are naturally drawn to
even proportions. When a piece of writing doesn't seem to sit well with you, the first
thing you may want to check is the proportion of the letters to each other.

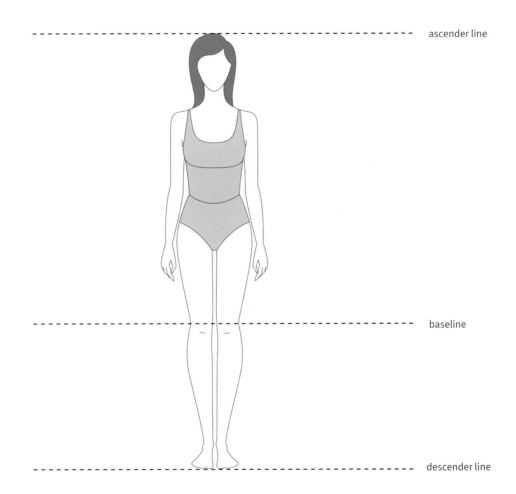

ascender line

baseline

descender line

Illustrating proportion

When you start learning how to form cursive letters, it makes sense to begin with an equal proportion in all three spaces – ascender, x-height and descender (see page 46 for definitions). We describe this as an equal ratio of 1:1:1.

Some people prefer to use a varied ratio such as a 2:1:2 proportion where, for example, the x-height measures 0.5cm (³/₁₆in) while the ascender and descender spaces measure twice this, i.e. 1cm (³/₈in).

Personally, I lean towards the ratio 3:2:3. This is where the ascender and descender heights are one and a half times taller than the x-height.

Different proportions are suitable for different purposes of writing. For instance, an equal ratio of 1:1:1 works well for a generic birthday card or greetings card, whereas a varied ratio of 2:1:2 or 3:2:3 suits a more flourished calligraphy style such as for wedding stationery.

1:1:1 ratio	*tranquillity*
2:1:2 ratio	*tranquillity*
3:2:3 ratio	*tranquillity*

Demonstration of different x-heights

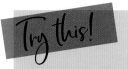

DRAWING YOUR OWN GRIDLINES

It is a really useful skill to know how to draw your own gridlines and it helps you visualize the proportions you are using to form your letters.

Measure and draw out the calligraphy lines, working your way from 0.5cm (³/₁₆in) to 1cm (³/₈in) x-height. As mentioned above, you probably won't use an x-height larger than 0.8cm (⁵/₁₆in), but it's good to practise working up to 1cm (³/₈in).

Follow these steps on **Practice sheet 1: Drawing your own gridlines**:

1 Decide on the measurement of your x-height. For me, I prefer 0.5cm (³/₁₆in) to begin with.
2 Draw two horizontal parallel lines, 0.5cm (³/₁₆in) apart. Mark that space with a small 'x'. This will be your main writing zone.
3 For a 1:1:1 proportion grid, measure another 0.5cm (³/₁₆in) above and below the two parallel lines you drew in step 2. You should now have four lines and three rows.

If you prefer a 2:1:2 scale, you can double the top and bottom rows to make them 1cm (³/₈in) (twice the height of the x-height). Similarly, if you'd like to try the 3:2:3 ratio, multiply the x-height (0.5cm/³/₁₆in in this case) by one and a half times and you'll get 0.75cm (⁵/₁₆in).

Varying proportions

These examples show the word 'Calligraphy' in different proportions. The top example shows the letters in the ratio 1:1:1. In the middle, the ratio 3:2:3 is used. The lower example uses the ratio 2:1:2.

Try this!

SITTING

Imagine that you're at the bank and you've been asked to fill out a form. How would you position your paper?

Nine times out of ten, people have their paper slanted at an angle. For right-handers, your paper leans to the left and the opposite is true for left-handers. There isn't a specific angle recommended for slanting your paper, so whatever feels most comfortable for you is what I would suggest. We're trying to work with your natural posture as much as possible.

Now you have positioned your paper, try moving your chair and body to sit in the same direction as your paper. Once you're settled, you'll notice that the moment you moved into this new position, your elbow came closer to, or even rested on, the table.

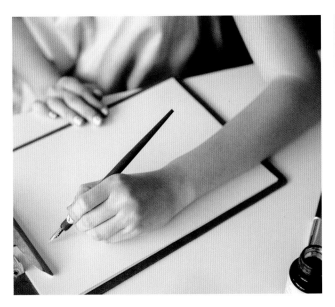

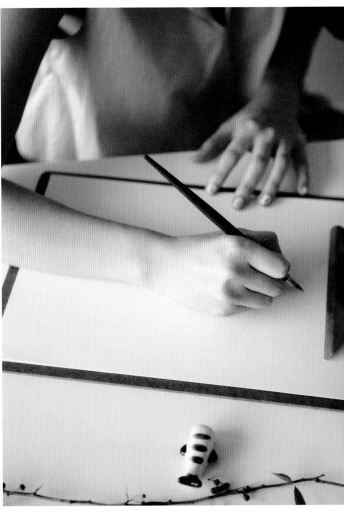

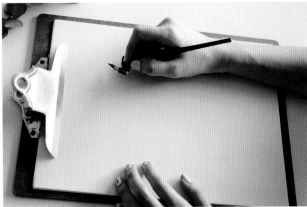

Paper positioned on table for left-handers (top) and right-handers (above)

Here you can see the correct position of the body, arm and chair relative to the table. Leaning your elbow on the table helps with weight distribution

WEIGHT DISTRIBUTION

Sit in your usual position, grab a pen and write down your address. While you're writing, observe which part of your arm the weight of your body is resting on. Chances are, the pressure will be exerted on your hand, or even the tip of your pen.

Now imagine replacing the pen in your hand with a delicate nib that won't take kindly to being subjected to this much force over a period of time. In addition, we need to acknowledge that it's highly possible we won't be angling the nib correctly at the start.

The point of this exercise is to show you the importance of distributing the weight of your body evenly across your arm. This is imperative because it widens your range of movement. It also prevents the tines of the nib from crossing, which will spoil your nib.

With your writing elbow on the table, you'll notice that you can now rest on it instead of your wrist. Immediately, we're moving the unnecessary pressure from your nib to your elbow.

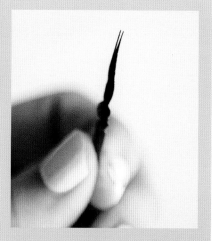

The tines of the nib are crossing

RANGE OF MOVEMENT

With the same pen, try drawing a circle as big as you can. You'll notice that you're limited when the circular movement happens from your wrist and hand.

Now try again, but this time moving your entire arm with the elbow acting as a pivot so that you can make large, curving movements. Compare the two: you'll find creating larger circles much easier when you use your whole arm.

Here you can see that a large shape can be drawn when you move your whole arm

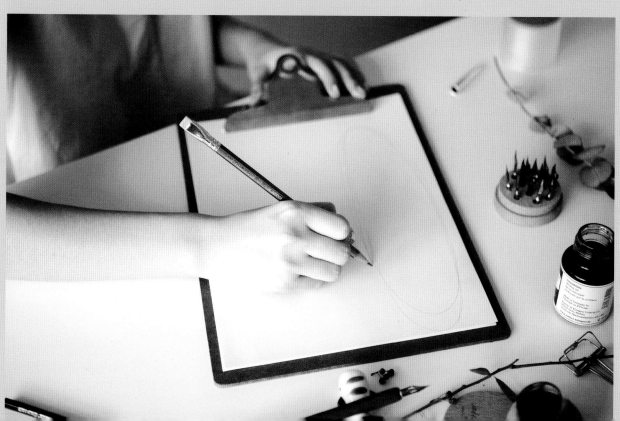

PEN GRIP, POSTURE AND ANGLE

Have you ever noticed how you hold a pen and where the end of it points to? Take a look.

Although there isn't much focus on pen grip in modern calligraphy, I would highly recommend using your first three fingers to hold the pen. This gives you greater flexibility and a wider range of movement. For some of us, this may feel like a huge loss of control over the pen, but experiencing this lack of mastery over your writing tool means starting with a clean slate. It allows you to acquire new skills without being tripped up by old habits. Changing your grip will take some time, so expect yourself to slip up and understand that your writing won't be the same as before. Allow yourself some space and time for growth.

For most right-handers, the end of your pen would be pointing outwards towards the right. As for left-handers, it could be pointing upwards or downwards at your shoulder. Yes, where the end of your pen points matters as well! This is because the nib is now an extension of your arm. The pen is almost parallel with your arm, with the end of it pointing towards your writing shoulder. Adopting this posture will allow your wrist to straighten out.

Try this!

PEN GRIP AND POSITION

Make sure you spend some time practising how you grip the pen with your first three fingers, checking where the end of your pen points and adjusting your posture. The more often you train yourself, the easier and more natural it will become to achieve the correct positions. Use the photos below to help you mimic the right grip.

Using your first three fingers to grip the pen

Pen position for left-handers

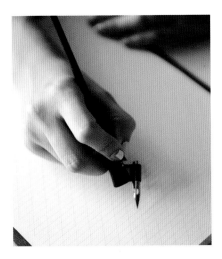

Pen position for right-handers

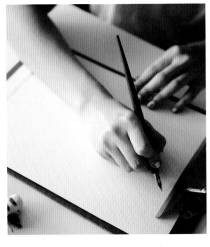

The end of the pen is pointing at your writing shoulder

WRIST MOVEMENT

A fun experiment to try is to observe how your wrist moves when you start writing. For some of us, our wrists automatically tilt downwards, sending the end of the pen back outwards. We don't want that. The process of conscious correcting can be frustrating, but it draws awareness back to our natural movements.

As for the angle of the pen to the paper, we usually aim for 30–40°. Personally, I hold the pen at an angle where my last two fingers can comfortably support the pen. What we want to avoid is holding it perpendicular to the paper!

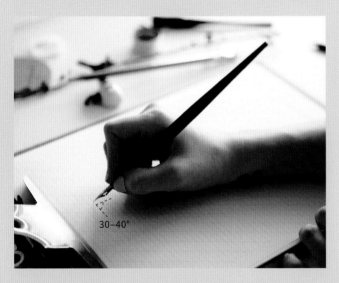

Look at the angle of the pen to paper, with wrist tilting downwards

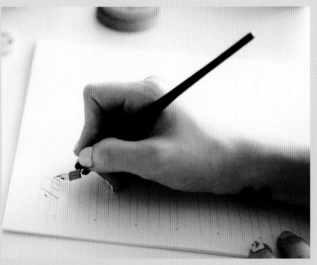

The angle of the pen to paper when using an oblique holder

Let's shine the spotlight back on our non-writing hand – it plays an equally important role in the process of writing too. It should be resting lightly on the paper, holding it down. This also reduces the chance of a shoulder ache from leaning too heavily towards your dominant side.

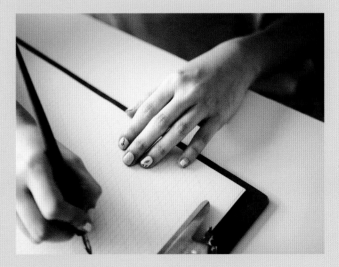

This is the correct position for your non-writing hand

USING THE NIB

As you send the nib upwards, it creates thin lines. These are called 'upstrokes'. Dragging the nib downwards while applying some pressure produces thick lines. These are known as 'downstrokes'.

When strokes are formed individually, you are unlikely to experience any transitional issues. However, when you attempt to create even a single letter where turns and pressure changes are involved, you may start hearing sharp scratches.

The first thing you'll want to do if you hear the nib click is slow down. Reducing your speed gives you time to notice these errors and adjust your posture accordingly.

Whether the nib is upright, or at an angle, it should point in the direction of the slant you're writing in. To ensure that happens, remember that:

The pen is an extension of your arm.

In this posture, you're able to flex the nib smoothly with each downward movement. The ease comes from the fact that both tines are bearing the pressure equally, sitting next to each other. What you really want to avoid is having one tine below the other in a downstroke. This will subject the bottom tine to more pressure, causing it to wear out faster.

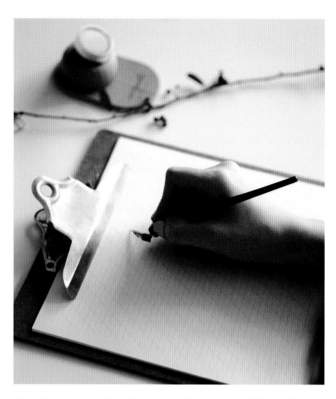

The nib points in the direction of the slant of the grid

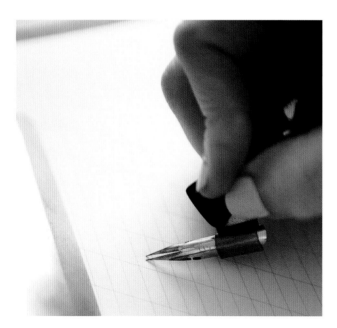

The tines are equal. This is what you are trying to achieve

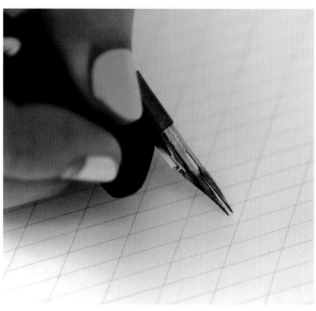

The tines are unequal. Try to avoid this

RECAP POSTURE

It's time to put everything we've gone through so far into action. Here are some reminders to guide you:

1 Notice the position of the paper.
2 Move your chair and body to sit facing in the same direction.
3 Grip onto the nib holder with your first three fingers. The nib holder should be in between the index and third finger, propped up by the thumb.
4 Position your writing arm parallel to your body.
5 Remember: the pen is an extension of your arm.
6 Check to see if the nib holder is sitting in the nook between your thumb and index finger.
7 Angle the pen to about 35–40° to the paper.
8 Make sure that the vent of the nib is facing forward.

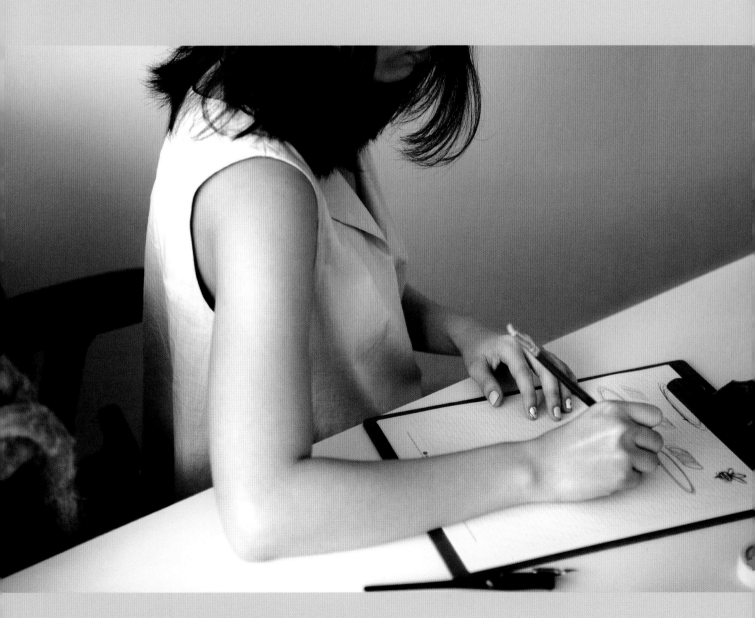

Basic strokes

WARM UP

It is a good idea to begin every writing session with a quick warm up. In fact, warm-up exercises can be done anywhere, as long as you have a piece of paper and a pencil. For more seasoned practitioners, you can use the pointed nib.
See **Practice sheets 2 and 3: Basic strokes**.

The warm up wakes your body up, practises the arm movements and checks your posture. While normal calligraphy writing requires both arm and finger movements, we're focusing on the arm because we've been writing with our fingers our whole lives so we are confident with that part!

As you write, don't forget to breathe!

Remember, warm-up exercises not only help with writing techniques but bring you into the headspace of becoming more aware of your body movements. As you do them, don't forget to check:

- Am I holding my breath?
- Is my neck relaxed or am I straining it to one side?
- Are my shoulders relaxed or tense?
- Am I gripping the pencil too tightly?
- Is my non-writing hand relaxed?
- If I'm crossing my legs, are they relaxed or crossed tightly?

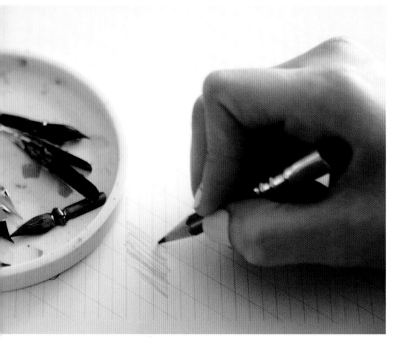

How to draw the up and down lines

Straight lines

Let's start with the most common stroke: the straight line. If you're using lined paper, set two rows as your height.

Your straight line can be upright or slanted to your preferred angle. I usually draw mine at a 54–55° slant because that's how I write naturally. Let's focus on the up–down movement to create a continuous row of lines packed as tightly together as possible. It's almost as if you're trying to shade this space using up and down lines.

For the majority of us, we'll notice the movement happening in our fingers. However, let's challenge ourselves by trying to creating these lines by moving your arm instead. Imagine someone pulling and pushing the back of your sleeve. This will send your arm forward and backwards, with your elbow gently rubbing against the table.

If it helps, draw longer lines instead, even lines as long as the paper. When you find yourself attempting strokes on a larger scale, you'll notice that your arm movement kicks in. After a few uninterrupted long lines, slowly shorten their length to fit back into your predetermined height. As you work on this arm movement while drawing lines, you'll notice that your triceps are actually powering the action.

Ovals

The second shape that we'll draw in our warm up is the oval.

Imagine that you're drawing a slinky/spring. Within your set perimeter, create an unbroken string of ovals that overlap each another.

Is the movement coming from your arm or is the action happening from your wrist up? Is your elbow still resting on the table?

Again, if you find moving the arm challenging, draw an oval as big as your paper, then reduce the size from there.

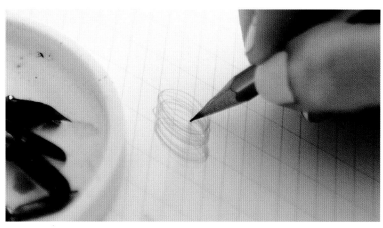

Horizontal ovals

The final shape we'll be looking at is the horizontal oval. To help you, imagine that your arm is a windscreen wiper which moves from left to right and back continuously. For even longer ovals, you can rotate your paper landscape – that is, arranged so that the paper is wider than it is tall.

In the example opposite, we'll be reducing the length of the ovals as you go from top to bottom, almost as if you're drawing a tornado!

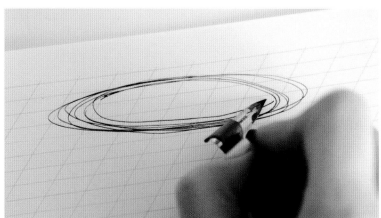

If you'd like to mix things up, try using straight lines, ovals and horizontal ovals to draw simple illustrations without lifting the nib. You could try something fun like a carrot, a rabbit, or a bunch of grapes.

As mentioned at the start of this section, the warm-up exercises are best done with a pen or pencil. When you're more comfortable with the movements, try these exercises with the pointed nib. The same goes for the subsequent strokes – use a pencil or a ballpoint pen until you're comfortable with the forms, after which you can move on to the nib and pen.

[57]

UPSTROKE AND DOWNSTROKE

To create the upstroke, guide your nib gently upwards. Avoid exerting too much pressure, otherwise the tines will start to open, causing the nib to catch on the paper fibre. If you hear a clicking sound and feel significant resistance as you draw the line, slow down and reduce the pressure on the nib.

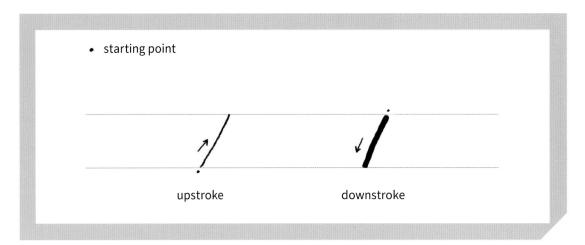

A common mistake here is flicking the nib as you end your line, to make the stroke more manageable. This abrupt movement results in a sharp finish to your line, as shown in the two examples below. Instead, maintain control of the nib from start to finish.

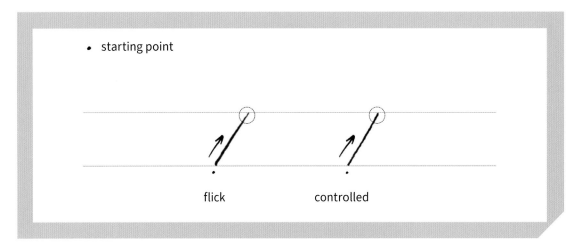

To practise the up- and downstroke, see **Practice sheet 2: Basic strokes**.

As for the downstroke, begin by opening up the tines of the nib to create a square top. Without closing the tines, pull the nib downwards and end the downstroke slowly. If you prefer a pointed tip at the bottom, allow the tines to close gradually as you go.

A flat base is created when you maintain the opening of the tines, only to close them right at the bottom before lifting the nib off the paper.

The nib is opening on a downstroke
This is notable because the ink has run out. I let that happen to demonstrate the nib opening. If the nib is full of ink, you can't see the split as it is too dark to be visible.

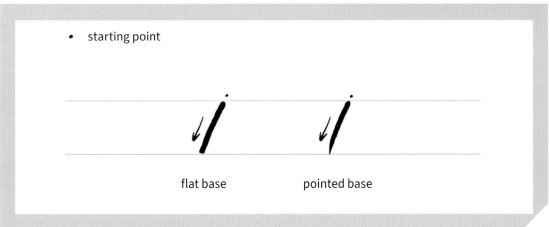

• starting point

flat base pointed base

ENTRY AND EXIT STROKE

Also known as lead-in lines, these are the lines that begin and end the letters, possibly playing the role as the joining stroke. Working on these strokes requires a fair bit of imagination.

The entry and exit strokes are essentially different parts of an oval, as you can see in the image below. For your initial practice, you may want to begin by drawing or printing out ovals and writing over the respective segments.

When you analyse the strokes you have made, check if either stroke is too straight or too curved.

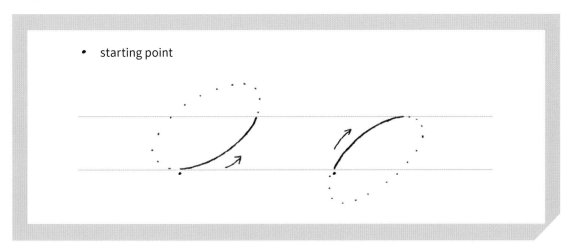

• starting point

UNDERTURN, OVERTURN AND COMPOUND CURVE

Before you attempt a curve, I would always encourage you to try it using a pencil first. As you draw, observe the flow of your pencil. You will be creating thick and thin lines in one stroke, so take notice of when pressure is added and when it is lifted. When you feel ready, have a go with the nib.

 To break these turns down into manageable steps, I use what I call visual 'signposts', which serve as cues when I am writing. I like to draw a dotted line about three-quarters down the left side of the underturn shown below. This is the point just before the turn, and I liken the process to driving a vehicle – slow down before you navigate a turn. The overturn relies on the same principles, but in the opposite direction. Moving from an upstroke to a downstroke, pressure should only be applied after you've finished the turn as marked out by the dotted line in the image below.

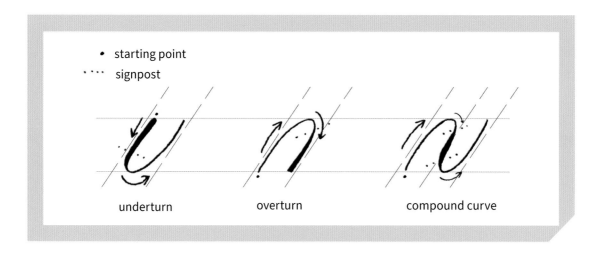

• starting point

···· signpost

underturn overturn compound curve

 As you reduce the speed of your writing, start lifting the pressure off your nib. This ensures a gradual progression in line thickness, preventing a chunky transition, which is an awkward progression from one part of the shape to the next. Moving slower helps you manage the transitions like the curve and the varying pressure.

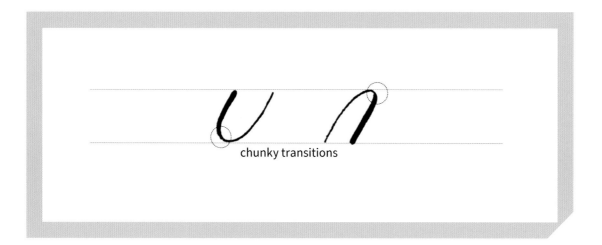

chunky transitions

If you combine both the overturn and the underturn, you get the compound curve. This challenging stroke is usually achieved in one go and requires all three straight lines to be parallel. Take time to consider the following points when working on compound curves:

- Are the straight lines parallel to one another?
- Are the curves turning at a consistent angle?
- Is the spacing between the lines consistent?

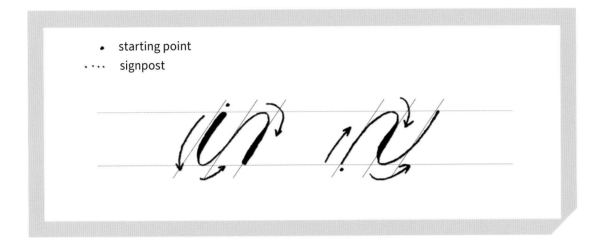

OVAL

One of the more complex shapes to perfect is the oval. Present in most letters, the oval requires a fair bit of focus when navigating both turns.

To draw an oval you will start at the top and you'll notice that the first direction you take is downwards. Avoid flexing the nib too much too fast. Instead, give it time to split gently for a smooth transition. Similarly, apply the same concept when you're handling the bottom turn going back upwards to the starting point.

Ask yourself the same three questions to ensure consistency:

- Are the straight lines parallel to one another?
- Are the curves turning at a consistent angle?
- Is the spacing between the lines consistent?

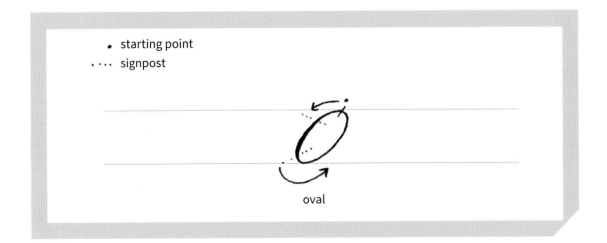

oval

ASCENDER AND DESCENDER LOOP

The ascender and descender loops are mirror images of each other. Start the ascender loop just above the waistline to give ample space for the shapes below. Guide the nib upwards first before looping left and back down.

 To create the descender loop, move in the opposite direction, dragging the nib down from the waistline before looping left and up to create the descender loop.

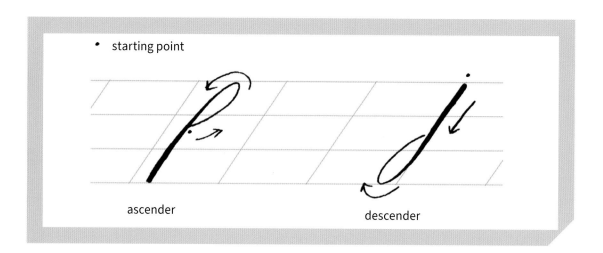

When seen closely, these loops aren't exactly an oval, but tear-drop shaped. Here are some other examples of how you can create variations for the ascender and descender loops to spice up your calligraphy.

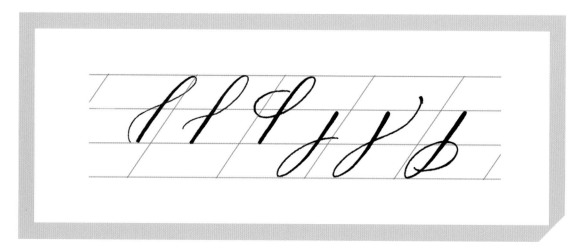

THE UNIVERSAL LINE OF BEAUTY

The 'universal line of beauty' is the backbone of most uppercase letters. It can be broken up into three parts with the first and last bit seen as the entry and exit strokes, leaving this middle section almost a thick straight downstroke. A good way to practise is to use the gradient on the grid as a guide to maintain the slant.

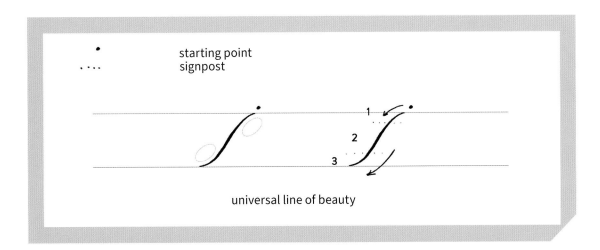

starting point
signpost

universal line of beauty

Take a closer look at the entry and exit strokes. You'll notice that they aren't exactly rounded. Instead, they curve just gently enough to wrap round an invisible oval, as shown in the image.

DECONSTRUCT, THEN RECONSTRUCT

Now that you've gone through the individual basic strokes, it's time for the fun bit: putting them together to form words. One thing I've found really helpful is to consider the letters as a combination of strokes. This way, it allows me to dissect the word into bite-size pieces for consistency.

Let's use the word 'minimum' as an example:

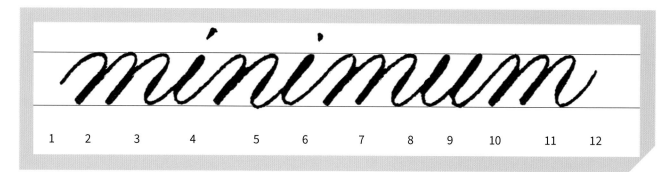

Even at this point, I wouldn't attempt to write the seven letters in one movement without lifting my pen off the paper. Instead, I break it up into twelve strokes. In the image below, you can see each of the twelve strokes.

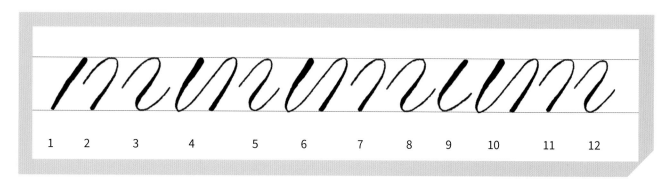

As I put ink to paper, I pause after every stroke and lift the pen off the paper to check for a few things:

- Is the spacing uniform?
- If I'm writing without a baseline, are my strokes more or less level?
- Are the repeating strokes identical?

Moving at a slower and more deliberate pace gives you the luxury of time to make minor adjustments for better accuracy in your writing.

Have a go at this exercise with a pencil first; you don't need to do it with a pointed pen if it distracts you from focusing on the shapes. Then, try out the same technique with another word, perhaps your name.

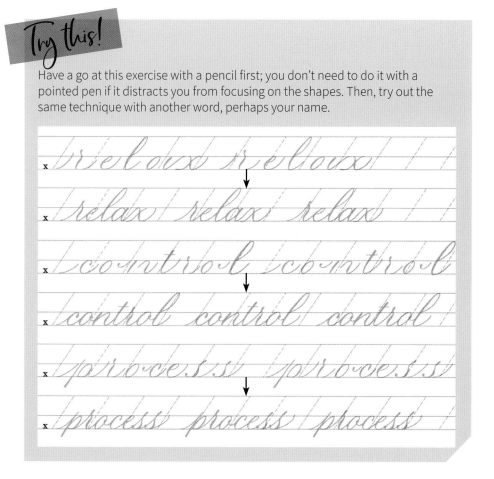

Eventually, breaking up words into a series of strokes will become second nature to you. But for a while, it may feel counter-intuitive.

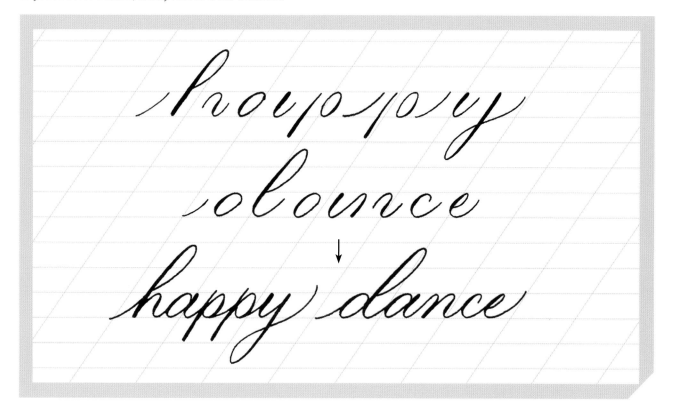

Lowercase

In the image below, you can see all twenty-six letters in alphabetical order. However, in terms of calligraphy, it is easier to consider the lowercase alphabet in groups, each of which finds commonality in a shape or trait. I have divided the letters into five groups: the oval group; the ascender group; the descender group; the repetition group and the exception group.

a b c d e

f g h i

j k l m n o

p q r s t

u v w x y z

ARTSYNIBS LOWERCASE

THE OVAL GROUP: a, c, o and e

The first group of lowercase letters, **a**, **c** , **o** and **e**, all have the oval shape in common, either the full oval shape or a part of it. Take note of how high the lead-in line goes. It doesn't actually hit the waistline.

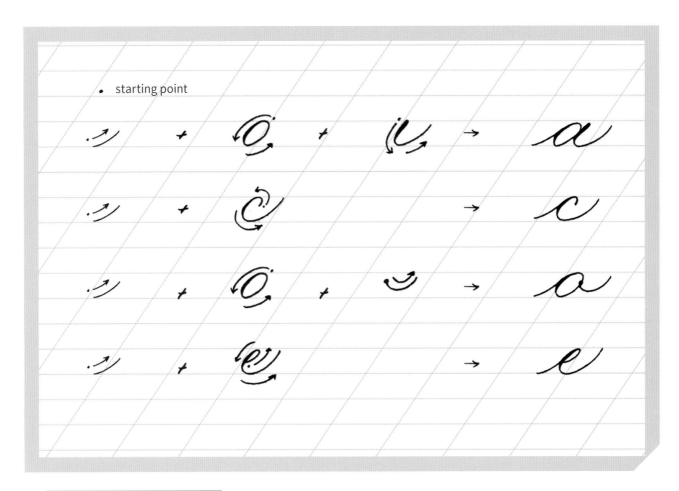

See **Practice sheet 4: The oval group**.

If you find that your ovals are looking too round, and more like circles, try thinking of making an up–down motion instead of a circular movement. In trying to trick your brain to guide your hand up and down immediately, this shortens your turning curve and creates a narrower body.

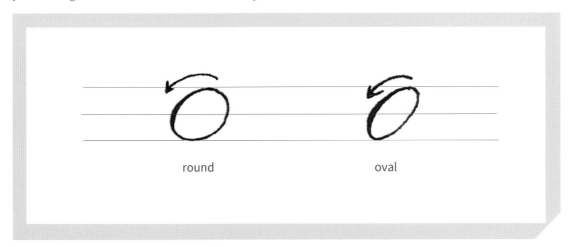

round oval

THE ASCENDER GROUP: b, h, k, l and d

The next group contains the letters that use an ascender loop: **b**, **h**, **k**, **l** and **d**.
The first four of these letters, **b**, **h**, **k**, and **l**, all begin with the same strokes –
the entry line and the ascender loop. To finish these letters, we begin at the
bottom of the ascender loop.

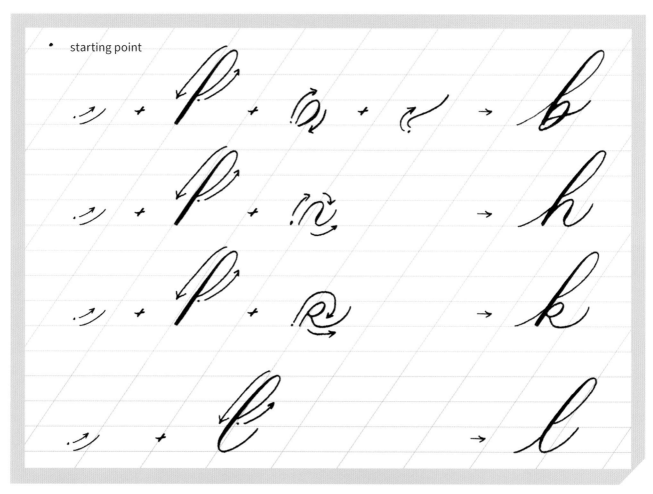

The letter **d** is constructed by joining an entry line, an oval shape, and the letter **l**.

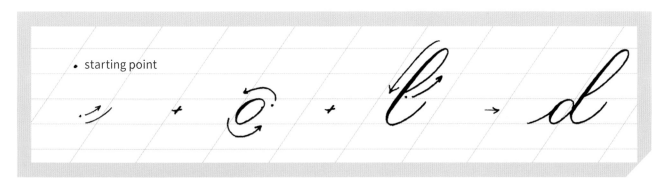

starting point

See **Practice sheet 5: The ascender group**.

Care is required when working out sensible proportions for this group of letters. Again, while there aren't standardized rules on what works in modern calligraphy, we simply want to avoid creating an unbalanced letterform.

The ascender loop starts just slightly above the waistline. While both top and bottom sections of the letter don't have to be equal in size, you don't want them to differ too much. This also affords both segments enough space to 'breathe'. The last thing you want is a letter that looks squished.

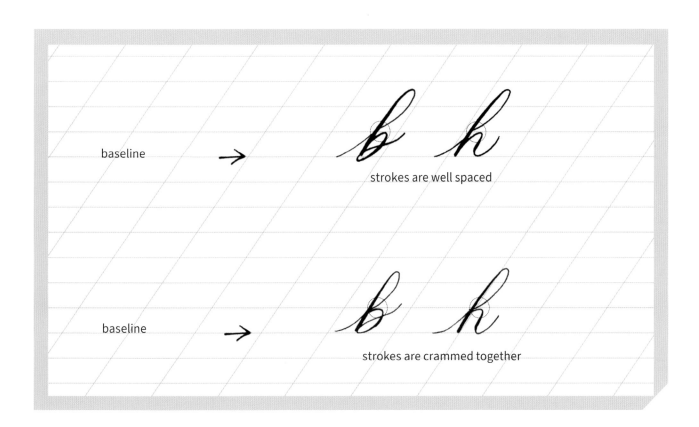

baseline

strokes are well spaced

baseline

strokes are crammed together

THE DESCENDER GROUP: j, g, y and z

In this group that uses the descender loop, we have the letters **j**, **g**, **y** and **z**. The descender loop is the mirror image of its ascender counterpart. With the letters **g** and **y**, we add a familiar stroke before the loop to create them.

The movement that creates the letter **z** resembles the number three, except that to make a **z**, you drag the tail out and up to form a loop.

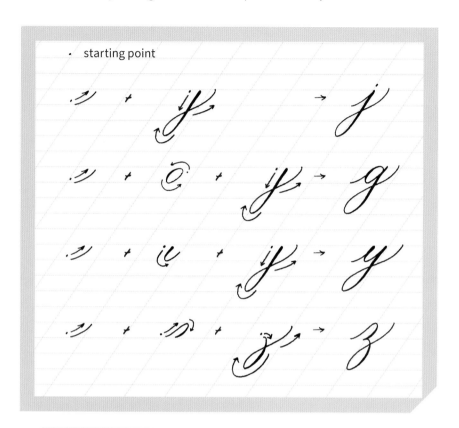

See **Practice sheet 6: The descender group**.

[72]

Ensure that the loop touches the descender line and cuts back into the main body below the baseline. This prevents the intersection from looking too crammed.

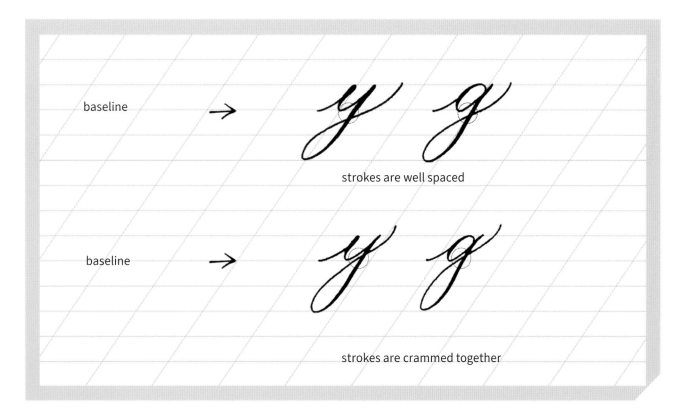

baseline →

strokes are well spaced

baseline →

strokes are crammed together

Try this!

RECAP OVALS, ASCENDERS AND DESCENDERS

Let's practise forming words using the following groups of letters that you have learnt: **a**, **c**, **o**, **e**, **b**, **h**, **k**, **l**, **d**, **j**, **g**, **y** and **z**. Using a mix of ovals, ascenders and descenders, you could try writing the words 'zeal', 'clock', 'goal', 'dogged' or 'each day', or think of your own words. Can you think of any words to practise that have more than six letters?

Use the Artsynibs grid on Practice sheet 20 for this exercise, or draw your own gridlines as you learnt in the 'Try this! Drawing your own gridlines' exercise on page 48. You can use a pencil or a pointed pen for this exercise.

See **Practice sheet 20: The Artsynibs grid**.

THE REPETITION GROUP: i, u, v, w, n and m

I named this 'the repetition group' because **i**, **u**, **v**, **w**, **n** and **m** are formed by duplicating the same strokes.

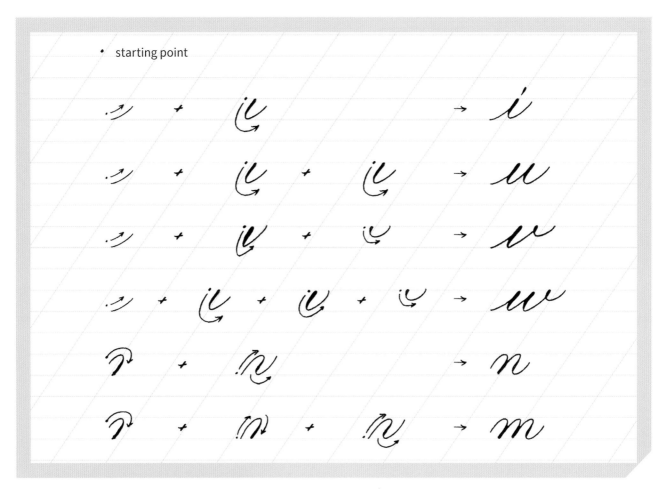

See **Practice sheet 7: The repetition group**.

THE EXCEPTION GROUP: f, p, q, r, s, x and t

Last but not least, the group of exceptions: **f**, **p**, **q**, **r**, **s**, **x** and **t**. These letters are simple but special.

 f is an interesting letter given that it sports both the ascender and a variant of the descender loop. Imagine it as a person. After your entry stroke, begin the second stroke by moving upwards. Without touching the ascender line, guide the nib backwards to create a face. Then drag the nib downwards for the letter's backbone.

 Just before you reach the descender line, round forward and upwards to create a belly, ending the stroke back where you started. To finish this letter, exit from where you completed the last stroke and outwards, almost like hands reaching out.

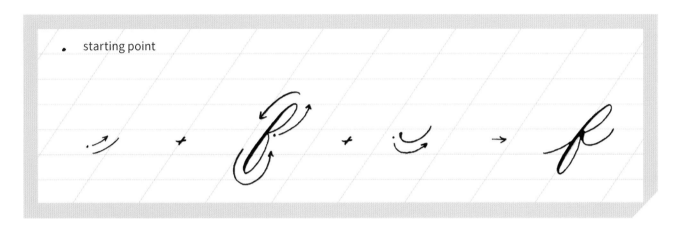

 An alternative option for **f** is to replace the bottom loop with a thick stem. Along with this, the exit line changes as in the example below.

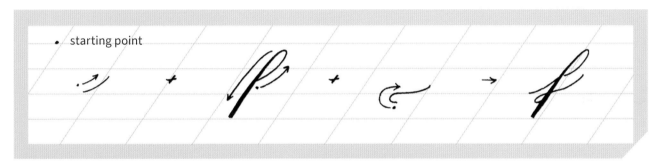

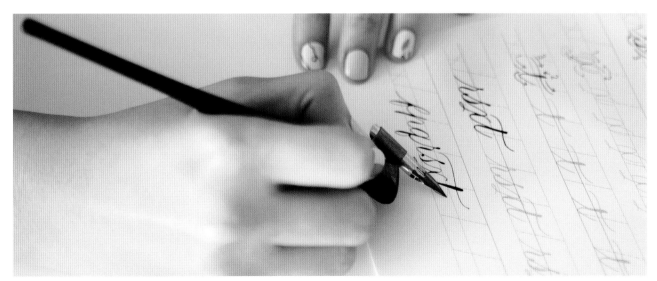

The entry line and a gradually thickening downstroke make up the letter **p**. It then wraps up with a compound curve or an oval, depending on which style you prefer. In the image below I demonstrate two variations. The first example has a more contemporary look, whereas the second example is more traditional in appearance.

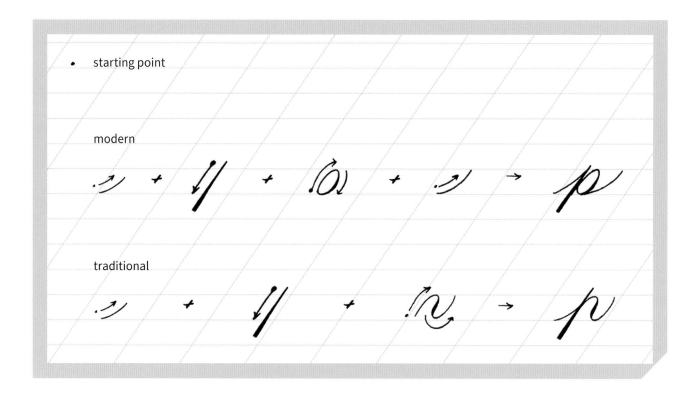

To make the letter **q**, you start with the entry line followed by an oval. Its descender loop rounds to the right instead.

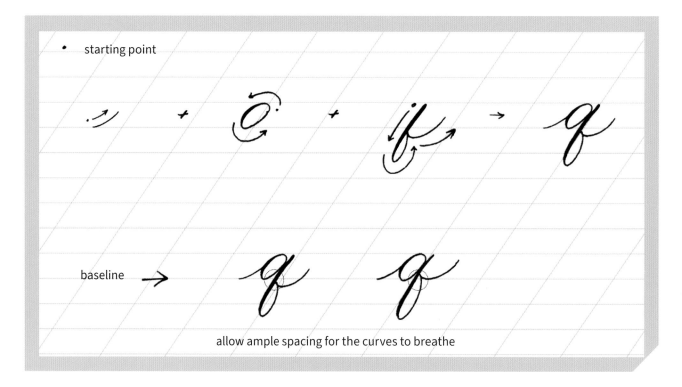

Although most of their lowercase counterparts sit comfortably within the x-height, the letters **r** and **s** don't. The highest point of both letters cross the waistline ever so slightly, seeing them standing a tad taller than the rest.

Take time to observe how **r** is drawn here. Just like **f**, **r** looks fairly different to how you would normally write it.

s runs in a very similar movement to the number five. However, the gentler bottom curve balances the entire letter instead of tipping it forward.

In the image below, I have illustrated what you need to avoid when creating an **r** or **s**. With **r**, notice that I've circled the top part to highlight that the two points are level. Instead, you want to make a stroke that runs downwards diagonally. For **s**, avoid giving it a 'tummy' that sticks out. I have circled the part that protrudes.

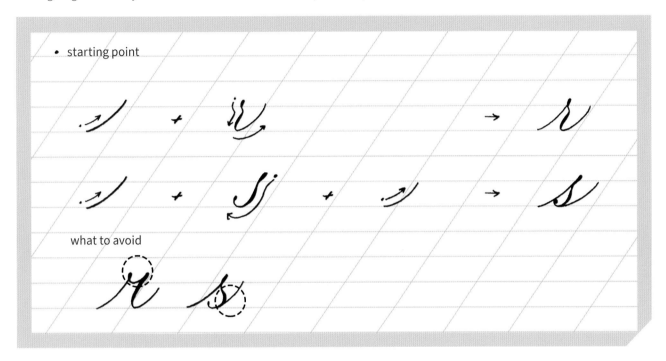

x is a letter that calls for strict parallel lines to ensure its balance. The first stroke is essentially a stretched out compound curve where the first and last straight lines run parallel to the slant. Summing up the letter is a thin downstroke (you can go from bottom up if you prefer) that also aligns itself to the gradient. In the image below I demonstrate two variations you can try.

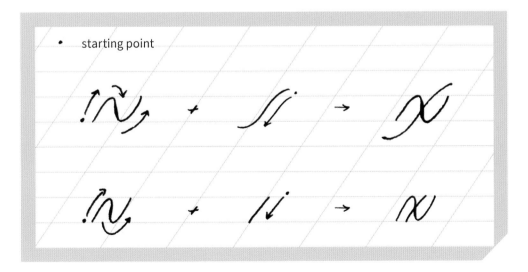

Last but not least is the letter **t**. It is a letter that is too tall to stay within the x-height, but not tall enough to hit the ascender line. Instead of a predictable and consistent thick downstroke, I begin with a broad tip at the top and gradually thin out the line. This is really down to personal preference, so I would encourage you to experiment yourself.

There are many ways to finish this letter as shown in the variations given in the example, but mostly importantly, find what works for your style of project.

There are a few things I would recommend that you avoid, and these are crossing the **t** right in the middle of the stem, which makes the letter look stumpy. To cut across the **t**, always go for the top quarter. Also, the stroke that cuts the **t** shouldn't be too wavy. Instead, try to make the middle part of this stroke as horizontal as possible.

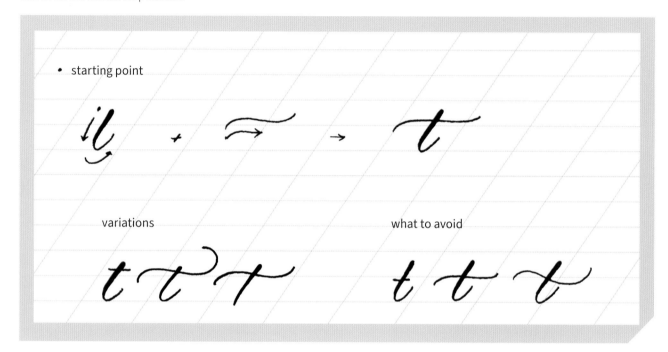

• starting point

variations what to avoid

See **Practice sheet 8: The exception group**.

RECAP REPETITIONS AND EXCEPTIONS

Let's practise forming words using the following groups of letters that you have learnt: **i**, **u**, **v**, **w**, **n**, **m**, **f**, **p**, **q**, **r**, **s**, **x** and **t**. Using a mix of repetitions and exceptions, you could try writing the words 'first', 'prim', 'quip' or 'fruit', or think of your own words. Can you think of any words to practise that have more than five letters?

Use the Artsynibs grid on Practice sheet 20 for this exercise, or draw your own gridlines as you learnt in the 'Try this! Drawing your own gridlines' exercise on page 48. You can use a pencil or a pointed pen for this exercise.

See **Practice sheet 20: The Artsynibs grid**.

Stringing letters together

I mentioned in the section on deconstructing, then reconstructing your word (see page 64) that it is best to break down a string of letters into a series of strokes. Make sure you stop after each stroke and lift the pen off the paper. This allows you to adjust your arm or paper if you feel that you can't stretch your hand further.

Just as we instinctively find breathing spots while speaking and singing, the same should be true for calligraphy. You wouldn't stop speaking halfway through a word. Instead, you'd pause naturally after finishing it. If we liken speaking a word to drawing a stroke, it doesn't make sense to stop mid-stroke to adjust ourselves. Much better is to finish the stroke, then pause to analyse.

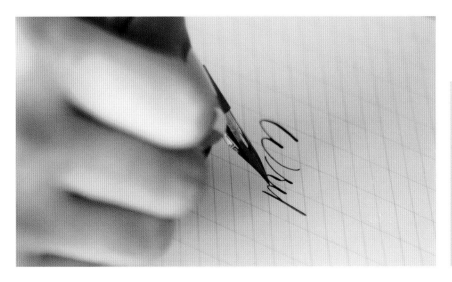

It's always easier to close up a gap than to open one.

This habit of drawing a stroke then stopping to reflect on it also encourages sensible spacing between letters. To facilitate this, don't forget to extend the exit line of each letter.

strokes are well spaced *calm*

strokes are crammed together *calm*

Uppercase

As we move into this uppercase section, you may be wondering whether uppercase letters are even more challenging than lowercase letters. However, from personal experience, I've found uppercase characters much easier to manage and more straightforward to create.

There are countless ways to draw uppercase letters, but the style shown below is what I use when I first introduce them to beginners. Look closely and you'll realize that most of the letters are very much like how you would usually write them. Perhaps, they're slightly more cursive or swirly than usual.

Just like the lowercase alphabet, the uppercase letters here are categorized into groups with similar traits. If you practise each row on its own, using the supplied practice sheets, you'll soon notice the common strokes or movements they bear.

See **Practice sheets 9–14: A, C and E; B, D, P and R; H, K, L and Z; T, I, O and Q; J, G, F and S; U, V, W, X, Y, M and N**.

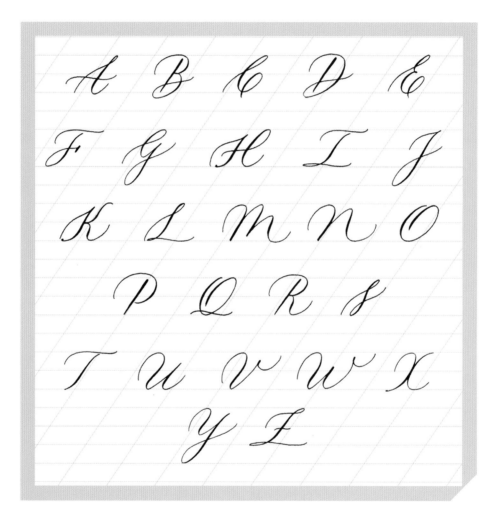

Before we take a closer look at individual groups of letters, I want to draw your attention to the stem of each letter. This is the main downstroke that runs from the ascender line to the baseline. The stem is usually the only and longest straight downstroke in the letter.

A, C and E

These three letters have the same entry stroke, which is an upstroke from the bottom left to the top right. As the stroke hits the ascender line, it loops back to the left and downwards, as seen in the arrows on **C** and **E**.

 A – The left side of the letter curves up as though it's following the outline of an oval, while the right side descends along the slant (as shown by the dashed line).

 C and **E** – These two letters have very similar proportions where the loop on top is smaller than the one below (as shown by the brackets). Look carefully and you'll notice that the top half of **E** rests just above the waistline.

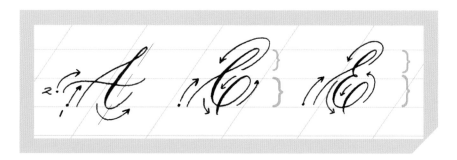

See **Practice sheet 9: A, C and E**.

B, D, P and R

The oval movement from left to right is what groups these four letters together. As you analyse how **B**, **D**, **P** and **R** are created, you'll realize that they begin with a stem, followed by a top cap that stretches from the left. The top cap of an uppercase letter refers to the oval-type stroke that covers the top of the stem.

 Just as in the group above, the top bit of **B** and **R** is the same size or smaller than the bottom. If you prefer a smaller top, you can always end stroke two slightly higher. However, it shouldn't go below the waistline otherwise it will tip the proportion of the letter.

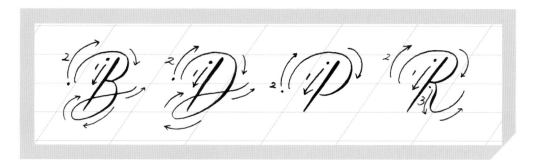

See **Practice sheet 10: B, D, P and R**.

H, K, L and Z

Despite the same entry stroke, these four letters can be split up into two subsections:

H and **K** – These two letters are similar in proportion, structure and movement of strokes. If you take a closer look, you'll notice that the left side of the letters is shorter than the right.

L and **Z** – The two things that differentiate these letters are the height of the entry stroke and the middle stroke that cuts across **Z**.

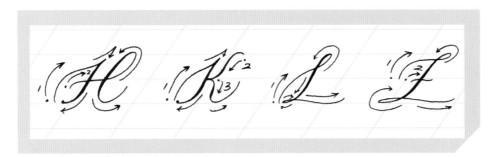

See **Practice sheet 11: H, K, L and Z**.

T and I

This is one of the easier groups of letters to form. Creating an **I** is essentially drawing an **L** below the top cap. It's worth noting that the stems in both letters run parallel to the gradient.

O and Q

Just like the group before, what differentiates these two letters is one stroke in **Q**. The main oval that features in each letter doesn't connect. Instead, it's almost as though you're drawing a stroke that's spiralling inwards.

Here, you need to pay extra attention to ensuring that the two downstrokes on the left side of the ovals are parallel.

See **Practice sheet 12: T, I, O and Q**.

J, G, F and S

To better dissect this group, we'll look at them two at a time:

 J and **G** – The descender loop links these two letters together in style. With a pencil (or your finger), trace out the direction of both letters and you'll notice that they flow the same way. Going deeper, **J** has a sharper turn than **G** at the top, where the entry line turns downwards.

 F – Ending this letter is the little downstroke right that's resting on the waistline. Albeit a short line, this stroke has to run parallel to the stem. Similarly, both horizontal lines in **F** are almost aligned.

 S – Imagine drawing the number 8: the movement that creates **S** is similar to that. Here, the stem of the letter isn't exactly straight, but more like a gentle wave that moves along the gradient of the grid.

See **Practice sheet 13: J, G, F and S**.

U, V, W, X and Y

My favourite group of all is this set of five letters. Apart from **X**, these letters are exactly how you would write them normally if you picked apart the entry and exit strokes.

 For all of them, drawing the entry stroke is like trying to recreate an oval. When attempting this, imagine that you've taken a section of an oval and used it as the entry stroke. It rounds from the left and straight into the main body of the letter.

M and N

Just like the group before, **M** and **N** use the same oval-like entry stroke. Slightly different from their more uniformed lowercase counterparts, these two uppercase letters are more playful with the height variation.

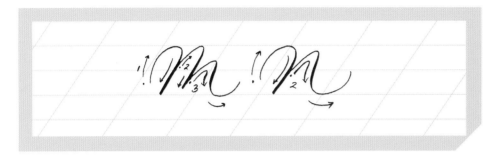

See **Practice sheet 14: U, V, W, X, Y, M and N**.

As I mentioned at the start of this section, I have demonstrated just one way to create uppercase letters. The easiest way to master and produce your own set of uppercase letters is to first write down how you would usually draw these letters. Then, standardize the entry and exit lines – notice how **U**, **V**, **W**, **X** and **Y** have the same curve on both sides.

Now you've had a go at all the uppercase letters, don't forget test them out in the various proportions that you read about on page 48.

VARYING THE PROPORTIONS

Now that you have tried the strokes as well as both lowercase and uppercase letters, you are ready to experiment with varying the proportions of the x-height relative to the ascenders and descenders. We discussed on page 48 the three ratios commonly used: 1:1:1, 2:1:2 and 3:2:3.

Let's take some time to find out what x-height works best for you. For me, I like to work with the 3:2:3 ratio, but you may get on better with a different ratio.

Refer to 'Practice sheets 17–19: Proportions', which have three types of gridlines that feature the different proportions we've spoken about. Here you can practise using different x-heights and experiment using both pointed pens and brush pens.

See **Practice sheets 17–19: Proportion 1:1:1, 2:1:2, 3:2:3**.

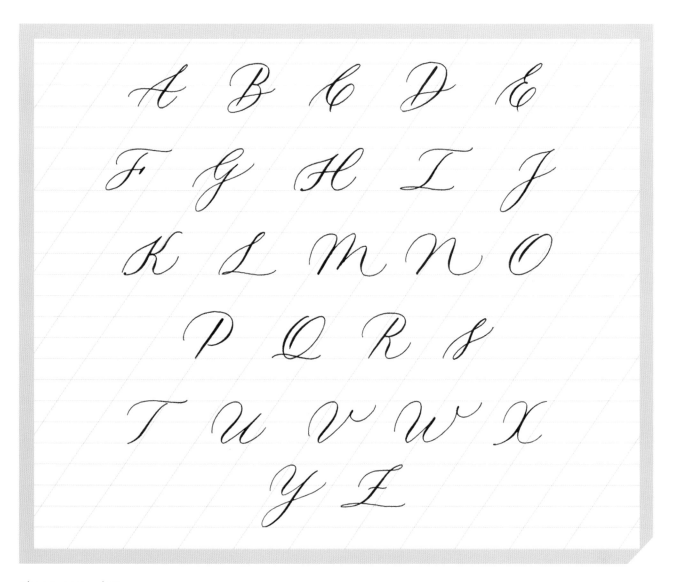

The uppercase letters

Varying your style

Rounding back to where we started: modern calligraphy advocates
individual style and creativity.
Once you have mastered the basics and are comfortable with your first set
of A–Z – the base template – you can build on that to design variations of it
for different purposes.

In this section I showcase a few different styles I've created over the years using
my own base template. These are variations that have evolved from my original
hand, rather than being an entirely different script. I hope they will inspire you to
have a go at extending your own writing too.

FORMAL

Suitable for easy reading, this style of calligraphy is ideal for official documents
like birth certificates, marriage certificates or other legislation. As legibility is top
priority in this variation, I tend to use it to address envelopes as well.

However, don't feel you can only use this design for formal purposes. If this
variation is what appeals to you, go for it!

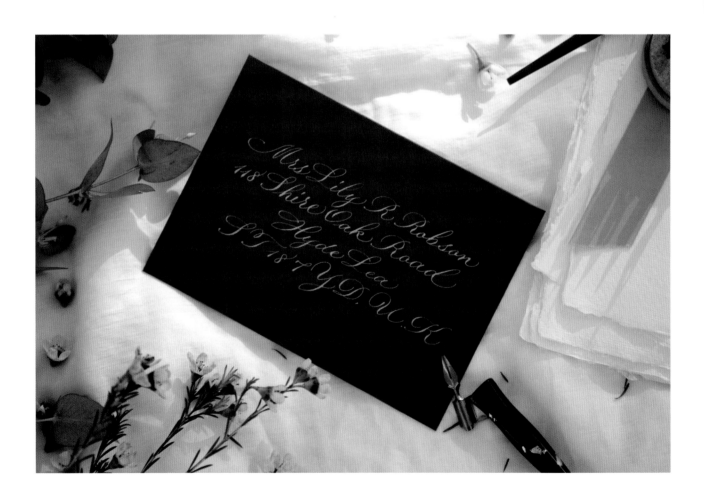

I will greatly
rejoice in the Lord
my soul shall exult
in my God
for He has clothed me
with the garments of salvation
He has covered me
with the robe of righteousness
as a bridegroom decks himself
like a priest
with a beautiful headdress
and as a bride adorns
herself with her jewels

ISAIAH 61:10

& DINNIE

To the Beautiful People
113 Pollard Street
4th Floor
Manchester M4 171
United Kingdom

CASUAL

The casual style works best for informal settings as it emanates a more laid-back vibe. Its flexibility in formatting and layout means it is an ideal variation for many to adopt and makes it a forgiving style to work with.

It's mostly seen on commissioned pieces and can even be easily recreated with a brush. This is also probably why this modern calligraphy style seems most common.

However, remember that no matter how casual or free-form your variation is, consistency is still key. If, for example, I choose to exclude the exit stroke for the **t** and **r** in my casual script, this needs to remain consistent throughout the entire piece (see image below).

Your mind will always believe everything you tell it. Feed it faith. Feed it truth. Feed it love.

ELEGANT

Mostly used for weddings, this style may look similar to its formal cousin. However, if you look closely, you'll realize that my version of the elegant style is slightly longer in height.

 Other characteristics of this variation are the longer exit strokes. The loops are slimmer and the strokes are thinner. It also boasts more spacing between letters. The letters themselves give the impression of flowing from left to right as you read each word.

A wedding menu with calligraphy headers

Handwritten calligraphy is great to personalize typed lists, making them more intimate for occasions like weddings.

Amanda S

SPEECHES

STARTER

Good conscience Lancashire grown wild mushrooms served on homemade crumpet with mushroom ketchup and cep

MAIN COURSE

Warm homemade hummus served with roasted roots, chargrilled cauliflower, butternut squash puree, lemon crumb and curried oil

PUDDING

Rich chocolate torte with vanilla cream

ALL THE CHEESES

Selection of local cheeses curated by Legrams Organic, artisan crackers and homemade chutney

Amélia R

SPEECHES

STARTER

Good conscience Lancashire grown wild mushrooms served on homemade crumpet with mushroom ketchup and cep

MAIN COURSE

Warm homemade hummus served with roasted roots, chargrilled cauliflower, butternut squash puree, lemon crumb and curried oil

PUDDING

Rich chocolate torte with vanilla cream

ALL THE CHEESES

Selection of local cheeses curated by Legrams Organic, artisan crackers and homemade chutney

ELABORATE

For a project that is lavish, the ornate flourishing in this variation is ideal. I generally employ the elaborate style to pen down the recipient's name on an envelope or an invite.

There are also times when this variation is used to create commissioned work. These pieces require a thorough planning process because space can be an issue. It's a time-consuming job to balance space and details, for example, where to insert the flourishing and what sort of flourishing to use.

A thank-you note
This stylized calligraphy piece is more than a letter. It can be framed and displayed as an artwork.

PROJECTS

The following eight projects are intended to inspire you to embark on your own creative projects. You can either follow the materials and step-by-step instructions exactly, or you can include variations of your own. I would encourage you to experiement with different colours and types of ink, as well as different sizes of paper. Unleash your creativity and have fun!

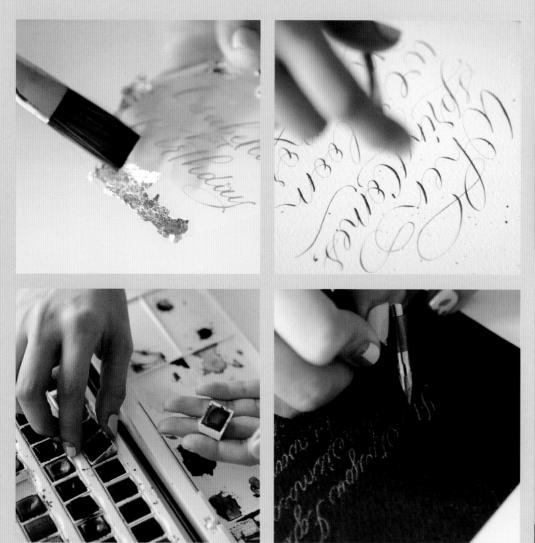

GOLD RINGS ON HANDWRITTEN ENVELOPES

I'm a huge advocate of 'snail mail' and it never fails to make someone's day when they receive a beautifully, yet simply, addressed letter through their letterbox. For this project you can use an artist light pad if you have one. Alternatively, you can use the Artsynibs grid template in the inside front cover of the folder.

MATERIALS

• White envelopes, to complement the size of your card •

• Artsynibs grid template •

• Leonardt Principal nib •

• Nib holder •

• Japanese sumi ink (or ink of your choice) •

• Gold ink •

• Ink dropper •

• Various sizes of bottle and container caps •

• Ruler •

• Pencil •

• Paper towel •

See **Practice sheet 20: The Artsynibs grid**.

Harper Robinson
92 Main Street
York YO88 9PZ
United Kingdom

INSTRUCTIONS

1 Choose a bottle cap and using the ink dropper, squeeze out some gold ink onto the rim of it.

2 Press the cap firmly on the envelope and repeat this process until you're happy with the number of gold rings transferred on the envelope. Leave the envelope to dry.

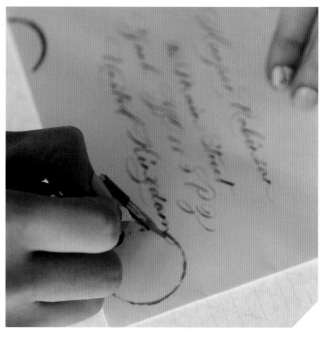

3 Lay the envelope over an A4 size Artsynibs grid (210 x 297mm or US 8.5 x 11in) and draw the lines on it with a ruler and pencil. If you are using a light box, lay the envelope over the grid and place them both on the light pad.

4 Using your Leonardt Principal nib and holder, write away! Remember to leave a sensible amount of space between each line. If you want to justify the text centrally, this will require some calculations.

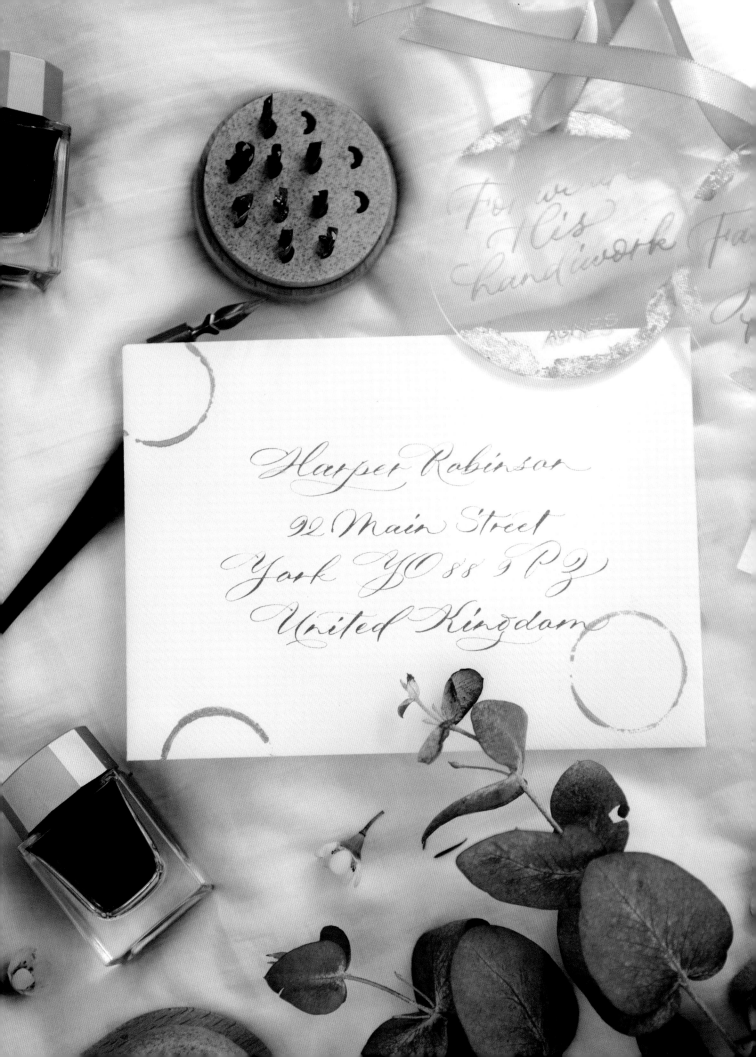

FULL CIRCLE ARTWORK

Spruce up your artwork by changing the layout of the text. This project doesn't require lines, so you need to adopt a go-with-the-flow attitude. The metallic coloured words will be encased in an invisible round frame, making it an eye-catching artwork! You could even experiment with changing the colour of your paper – black paper would create an impact!

MATERIALS

• White watercolour paper, 200gsm (size of your choice) •

• Leonardt Principal nib •

• Nib holder •

• Metallic ink (colour of your choice) •

• Paintbrush •

• Compass •

• Pencil •

• Eraser •

• Cup of water •

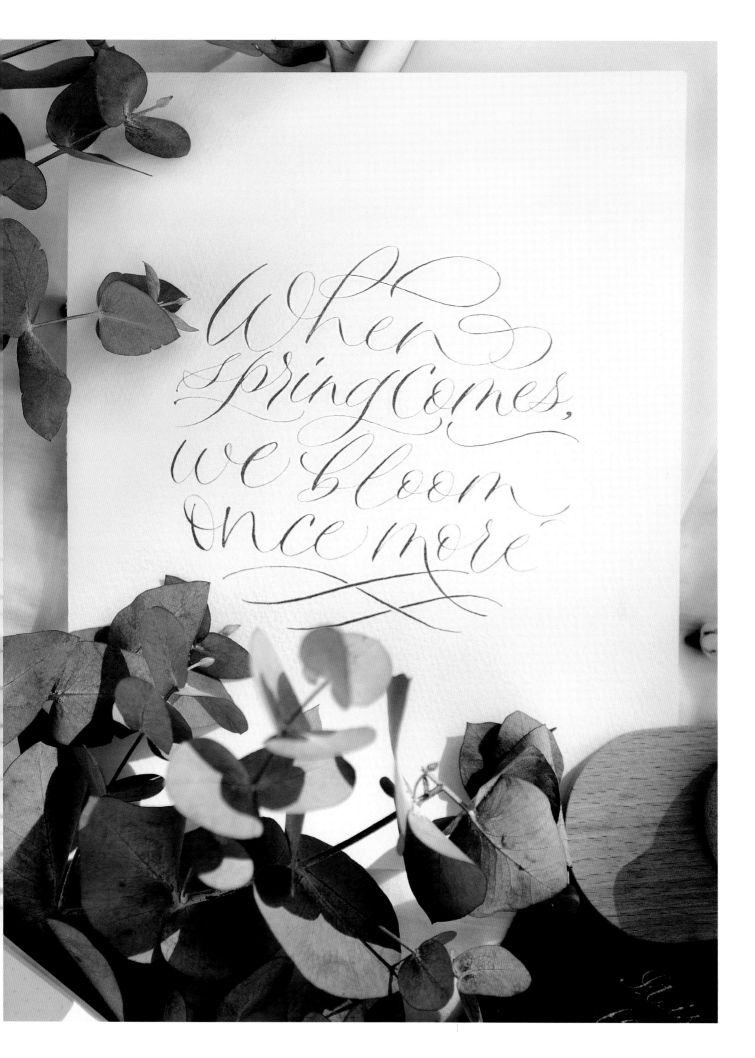

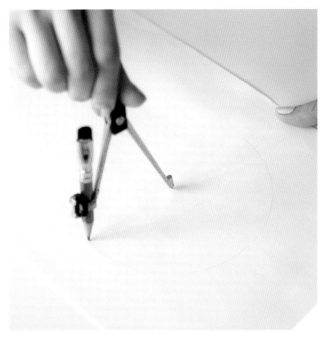

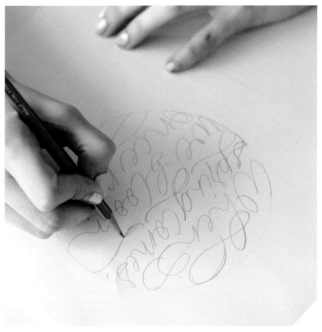

1 Using the compass and the pencil, draw a circle in the middle of your paper.

2 Sketch out your chosen text within the round frame, meandering the words along the curves of the circle shape.

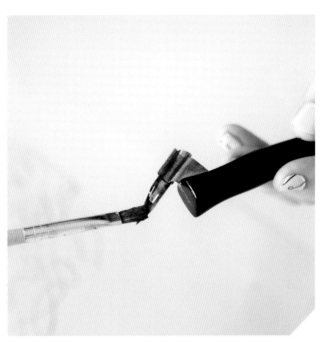

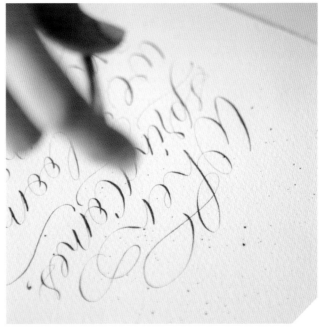

3 Once you're happy with the sketch, trace over it with the nib and ink. To use metallic ink, treat it like pans of watercolour ink. With a wet paintbrush, pick up the ink and apply it onto the nib. Leave the artwork to dry for as long as possible (I'd recommend leaving it overnight) before erasing the pencil lines away.

4 To add a bit more oomph to this piece, splatter some metallic ink around the text by flicking the brush or tapping the nib.

When
spring comes,
we bloom
once more

GLAMOROUS GOLD ACRYLIC GIFT TAGS

Here is a great alternative to paper tags which we attach to birthday gifts or Christmas presents, but usually throw away once the gift wrap has been ripped off. Before the next round of celebration comes, try making your own acrylic gift tags, rather than using disposable paper ones. That way, your recipient can reuse the tag as an ornament all year round!

This project can also be applied to acrylic sheets in all sizes. If your acrylic tags don't have holes, you can always make some using a home power drill.

MATERIALS

FOR THE CALLIGRAPHY

• Round or hexagonal acrylic tags, with holes in top •
• Ribbons, approx. 20cm (4in) long •
• Artsynibs grid template •
• Nikko G nib •
• Nib holder •
• Acrylic ink (I'm using gold) •
• Glass cleaner •
• Sealant spray (optional) •

AND TO GLAM IT UP

• Two paintbrushes (one of which will be used for the glue, so choose one you can spare) •
• Gilding glue •
• Gold flakes •
• Tweezers •
• Half a cup of water with a few drops of dishwashing liquid mixed in •
• Paper towel •

See **Practice sheet 20: The Artsynibs grid**.

Far beyond
jewels is
her value.

JULIE

For we are
His
handiwork

1 Remove the protective film on one side of the tag. This is the side you will write on. To prepare it, spray with the glass cleaner and give it a good wipe with paper towel.

2 Place the tag on the Artsynibs grid template with the side that you have just prepared facing upwards.

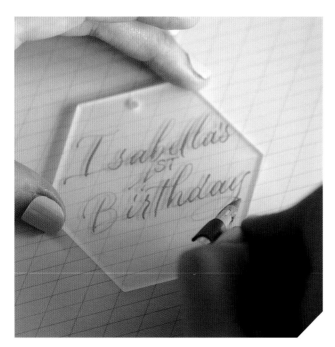

3 Using your Nikko G nib and holder, write your chosen quote or name with the acrylic ink. Leave the ink to dry.

4 With a paintbrush, apply the gilding glue to the edge of the acrylic tag in random patches. Once you have finished, leave the paintbrush in the cup of water and allow the glue on the acrylic tag to dry a little. The glue shouldn't be too wet for the next step.

5 Using a pair of tweezers, pick up the gold flakes and carefully place them onto the semi-dried glue. Cover all the patches of glue with gold flakes and leave to dry for five to ten minutes.

6 When the patches of gold on the acrylic tag are touch dry, brush off any excess flakes with the other (dry) paintbrush.

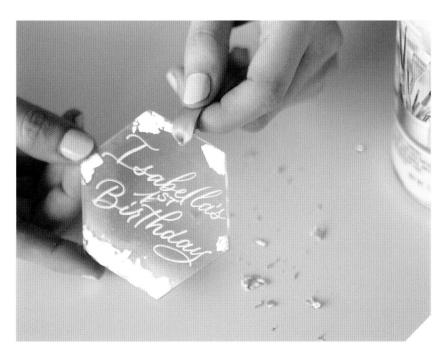

7 If you want to make sure that your gift tags are scratch-proof, spray a light layer of sealant across them. This adds a layer of protection for the gold flakes and ink. It will also give the gift tags a more frosted look. When the sealant is dry, thread your ribbon through the hole and tie a knot at the top to secure in place.

COLOUR SPLASH ARTWORK

If you're someone who embraces colour, this project will be right up your street. Personally, I enjoy experimenting with colour combinations like different shades of green, nautical colours and earthy tones.

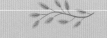

MATERIALS

• Watercolour paint (I'm using watercolour pans, but liquid and tubes work fine as well) •

• Paintbrush •

• Clairefontaine white watercolour paper, 200gsm •

• Nikko G nib •

• Nib holder •

• Pencil •

• Ruler •

• Cup of water •

• Paper towel •

• Artsynibs layout grid (optional) •

• Light pad (optional) •

See **Practice sheet 20: The Artsynibs grid**.

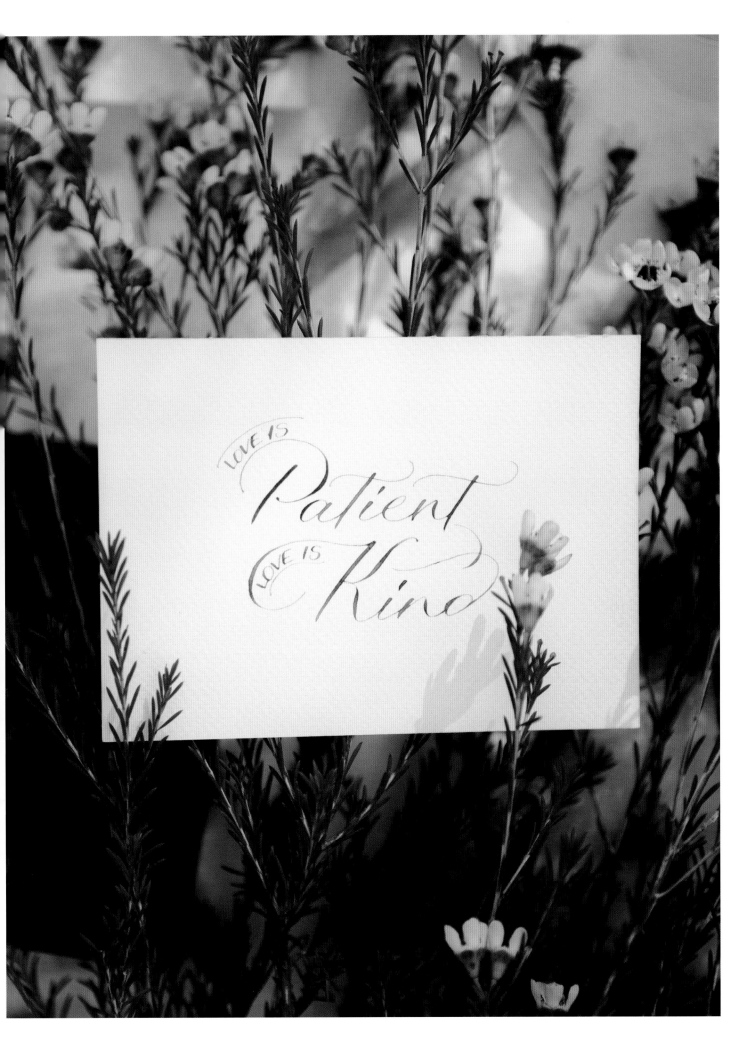

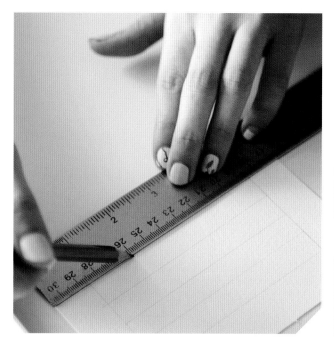

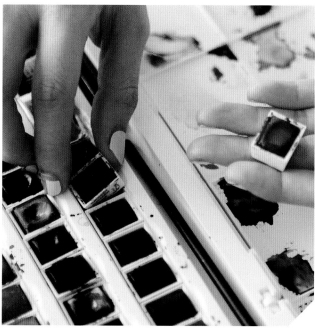

1 If you're working without a light pad, mark out your gridlines very lightly with a pencil and ruler. You don't want to make dark pencil marks because the watercolour paint may not be concentrated enough to cover them.

2 Sketch out your words on the watercolour paper. I have chosen the words, 'Love is patient, love is kind'. If you have a light pad, you can sketch it out on a piece of regular white paper first. Pick out two different watercolours to blend. I've chosen Blush and Payne's Grey.

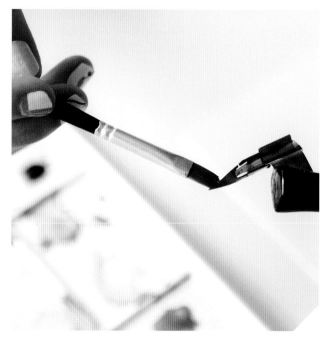

3 Pick out the Blush watercolour with your paintbrush and brush it onto the back of the nib to transfer the ink. Once the nib is filled with Blush, rinse the paintbrush and pick out the Payne's Grey watercolour. Transfer just a hint of it onto the nib and you'll start to see the colour blend there and then. Be careful not to let the darker colour overpower the lighter one. Once the ink in the nib runs out, refill it by repeating this step until your artwork is complete!

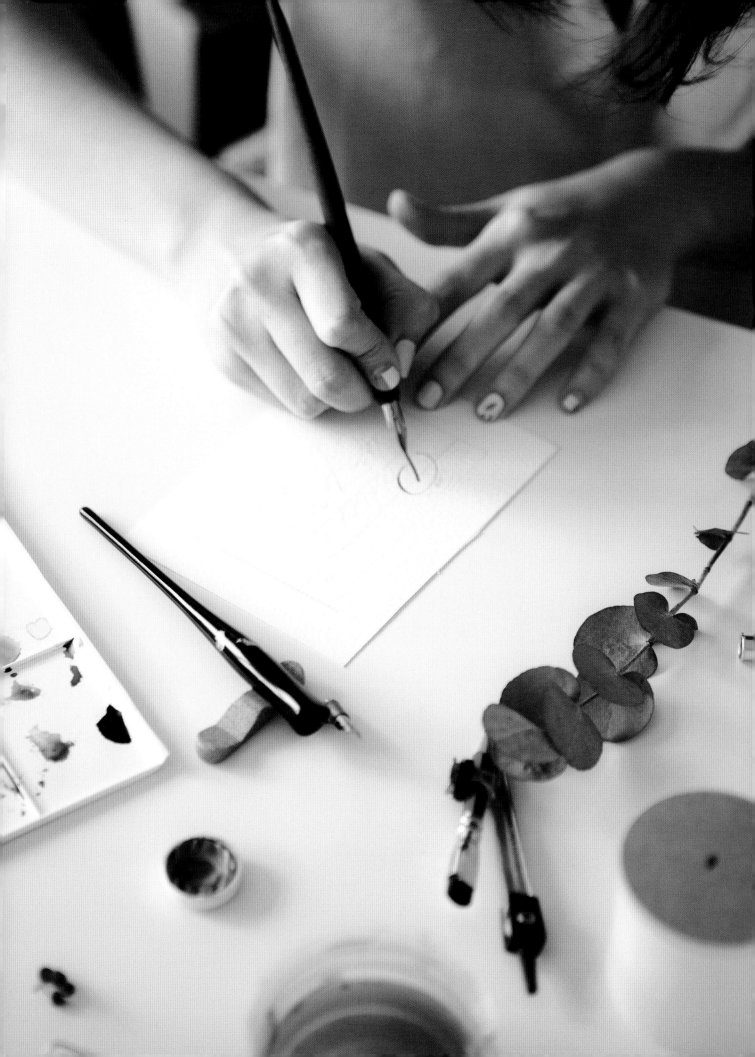

DIGITAL MONOGRAM

One of my husband's dreams is for us to design a family insignia at
some point. Being the more creative part of the duo, I've always tried to
persuade him to do away with the elaborate concept and in its place have
an elegant monogram with our initials.

Regardless of what we decide, the next step in the process is digitizing
the artwork. Once this is done, you'll be able to print your monogram on
any material that you can imagine!

MATERIALS

• Laser copy paper (I prefer this because it's smoother
and the lines come out cleaner after scanning, but
regular printing paper works too) •

• Scanner •

• Photo editing software •

• Japanese sumi ink •

• Compass •

• Pencil •

• Ruler •

• Light pad (optional) •

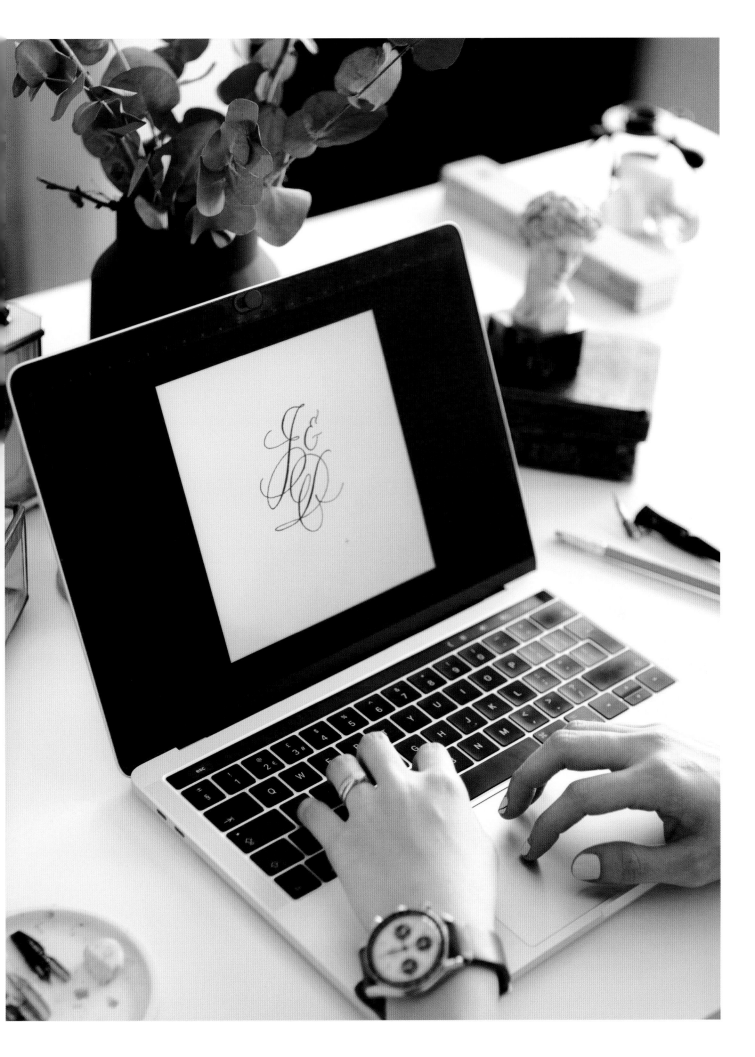

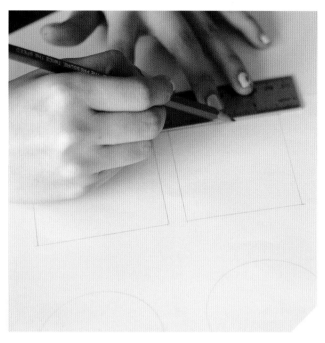

1 On the laser copy paper, draw a few circles and squares that measure 3.5cm (1⅜in) across. Working with frames like these will prevent the monogram from looking messy.

2 Sketch out your monogram designs. Play around with different styles and placement. You may even want to try a triangle or hexagon frame instead of circles and squares.

3 Get creative with the flourishes. Remember that the purpose of these loops is to balance the monogram on all sides, so stay within the boundaries of the frame! If you need to, you can always make the frame bigger.

4 Erase the frames that you drew in step 1. If you're working with a light pad, you can skip this step. With the nib and ink, trace out the monogram that you've sketched and perfected. Once the ink is dry, erase the sketch marks.

5 Scan your monograms to at least 300 dpi. Personally,
I double that to 600 dpi.

6 To edit the image in photo editing software, select and cut
the monogram out from the main image. If selection is tricky,
try darkening the image a little to make the shade of the strokes
more distinct. Once the monogram is separated from the image,
do a colour overlay and change it to black. Make sure that the
image is straight and that all the characters sit on the same line.

7 Depending on what you want to print the monogram on,
you'll need to save it in various file formats. To cover all bases,
I save my image as a .pdf, a .png and a .jpg. I also prefer to save
the design with a transparent background. This makes it easy if
you're printing on coloured paper.

DIY PLANT LABELS

I'm a houseplant lover and one of my favourite things to give as a house-warming gift is a pot of herbs. Apart from cooking with them, herbs have various medicinal properties and can serve as a great insect repellent!

In true Artsynibs style, I always include a calligraphy element in my gifts. This simple project will teach you how to spruce up this pot of herbal delight.

MATERIALS

• Thick watercolour or calligraphy paper, 200gsm •
• Nikko G nib •
• Nib holder •
• Japanese sumi ink •
• Scissors •
• Wooden craft sticks •
• Low tack, decorative masking tape
(I'm using washi tape) •
• Pencil •
• Ruler •
• Laser level (optional) •

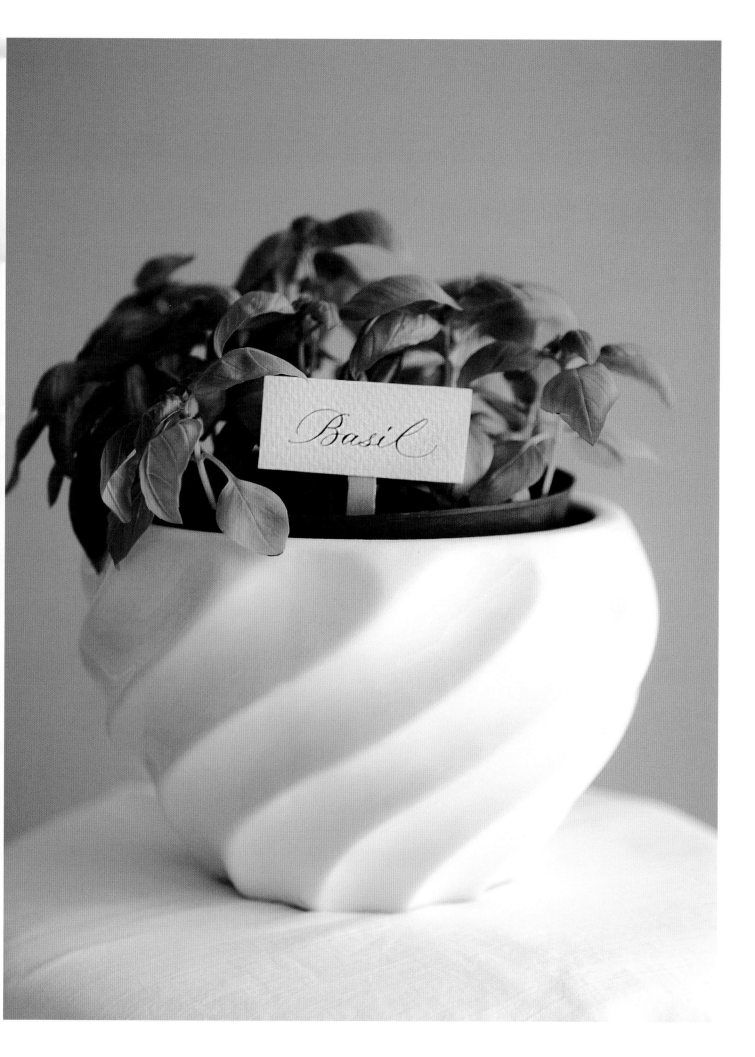

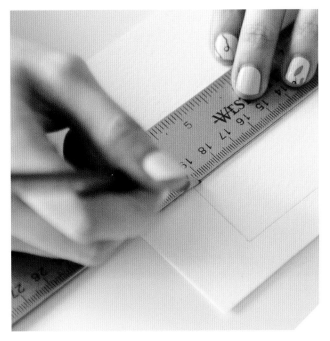

1 With the pencil and ruler, measure out your preferred label size. I am measuring a rectangle that is 7 x 3cm (2¾ x 1¼in).

2 Now, draw out the baseline. If you have a laser level, use it to find the baseline and draw it in. Sketch in pencil the name of the plant in a calligraphy style of your choice.

3 Go over the pencil sketch with the nib and sumi ink.

4 Once the ink is dry, cut out the label and attach it to the top of a wooden craft stick using the washi tape.

Repeat the steps above to create as many plant labels as you need and stick them into your potted herbs!

Rosemary Thyme

SIMPLE BANNER

For those of you who enjoy journalling or note taking, this project lets you in on a nifty trick to highlight your calligraphy without flourishing. To take it up a notch, we'll discover how you can create a curved banner!

MATERIALS

• Leonardt Principal nib •
• Nib holder •
• Walnut ink or Japanese sumi ink •
• Your notebook/notepad •
• Compass •
• Pencil •
• Eraser •

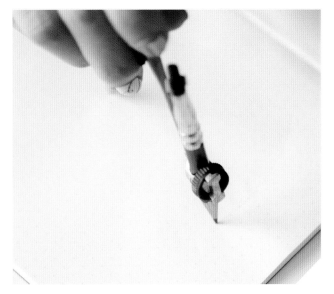

1 Using the compass, draw a curve where you'd like your calligraphy to go. Personally, I prefer a gentler curve.

2 Use the curve that you've drawn as your baseline and sketch out the word or phrase with a pencil. Here, I'm writing 'To Do List'. You may need a few attempts to centralize your writing.

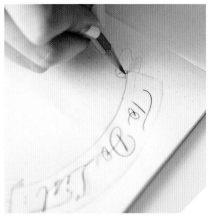

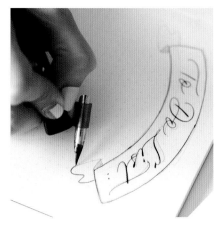

3 Write over your pencil calligraphy with the nib and ink.

4 With a pencil, draw a rectangle that wraps around your writing. Add the banner elements (refer to image) on both sides of the rectangle.

5 Trace over your banner with the nib. Once the ink is dry, you can erase your pencil draft.

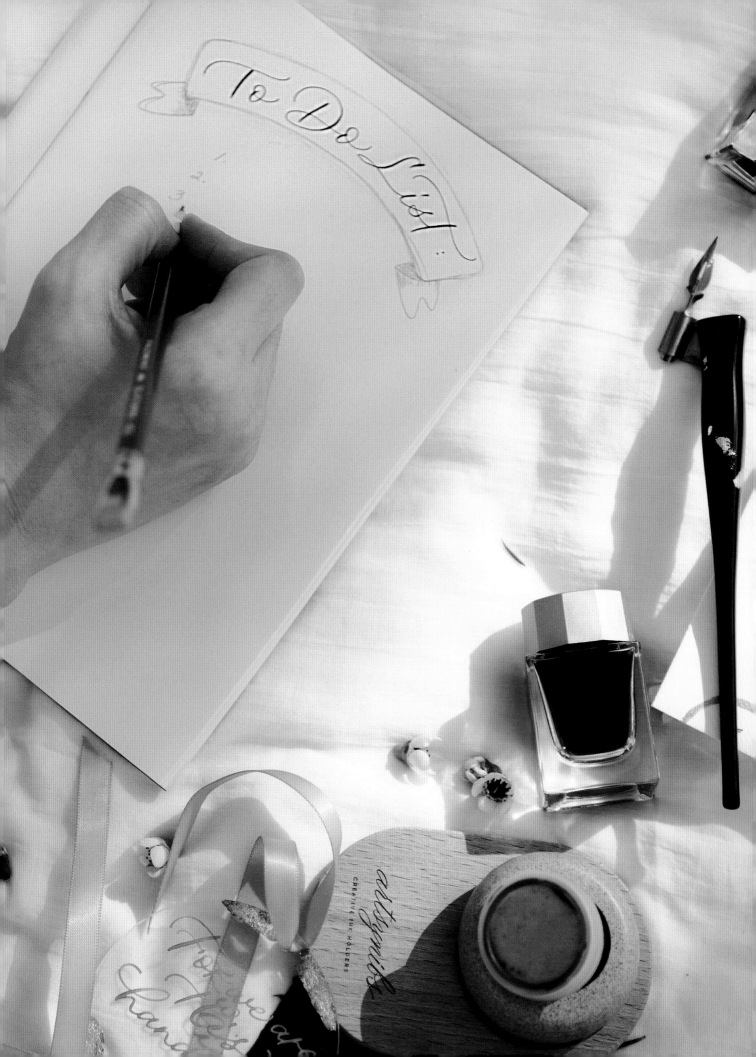

USING COLOURED PAPER

On days when you find drawing on white paper is too mundane, switch it up with coloured paper! In this project, we'll be exploring the process of drafting and creating an artwork on black paper, using metallic ink.

MATERIALS

• Black watercolour or fine art paper, 200gsm (size of your choice) •

• Regular white copy paper •

• Leonardt Principal nib •

• Nib holder •

• Metallic ink (I'm using Coliro Finetec, Moon Gold) •

• White chalk •

• Pencil •

• Eraser •

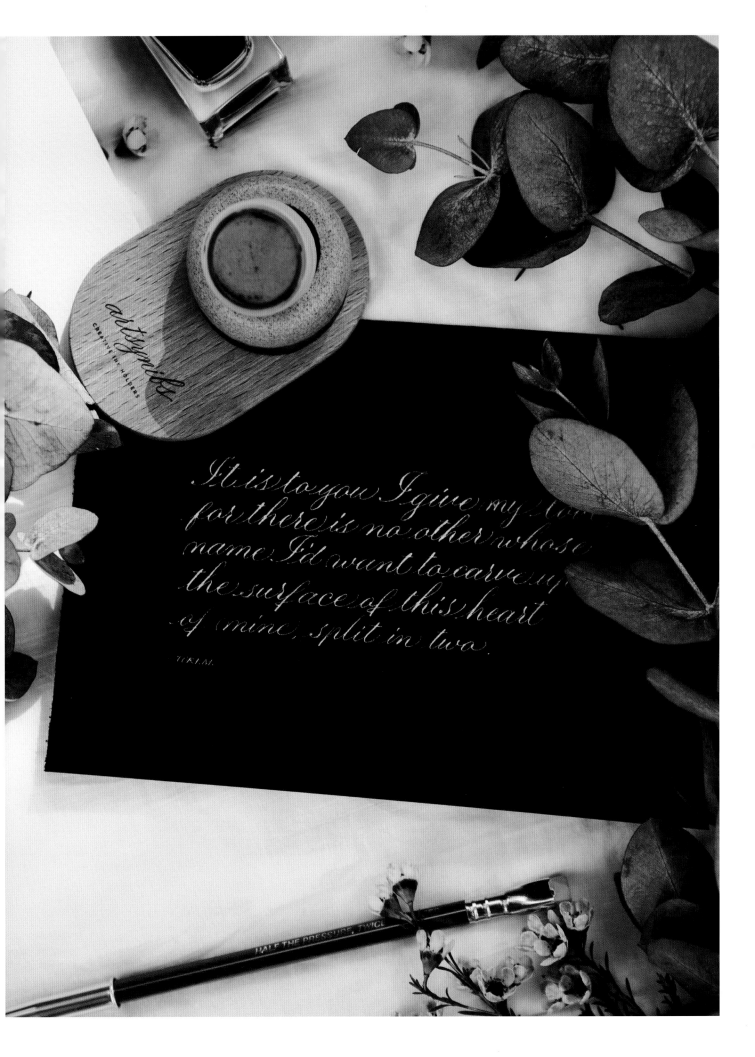

It is to you I give my love,
for there is no other whose
name I'd want to carve up
the surface of this heart
of mine, split in two.

1 On a piece of white paper, sketch out your calligraphy design in pencil.

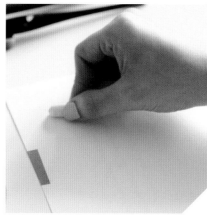

2 Turn your sketch over and on the blank side, rub the piece of chalk all over it. Make sure you cover the entire side of the paper with chalk, not just the writing.

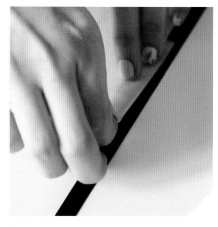

3 With the chalk-covered side of the black paper facing upwards, place the white paper you've been writing on over it, with the text facing you.

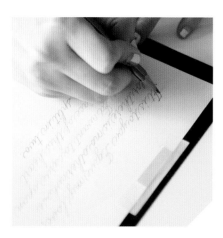

4 Trace over your draft again with a pencil. This should leave a chalk imprint on the black paper.

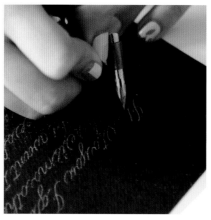

5 Now that you've transferred your draft onto the black paper, you can proceed to draw over it with the nib and ink.

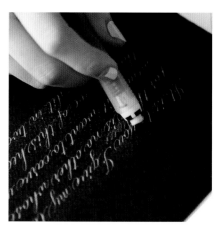

6 Once the ink has dried, gently wipe off or erase any visible chalk marks.

It is to you I give my love,
for there is no other whose
name I'd want to carve upon
the surface of this heart
of mine, split in two.

– TORI. M.

CALLIGRAPHY FAQS

HOW LONG SHOULD MY NIB LAST?

Unfortunately, there isn't a one-size-fits-all answer to this. It could be anything from a day to a month, as few as five pages or as many as twenty pages.

The lifetime of a nib depends on many factors, such as the manufacturer, the type of nib, your writing style, the ink used and the paper used.

What I can share with you, however, are telltale signs that your nib is on its last legs, and should be replaced, for example split tines, a scratchy nib or rust.

MY NIB IS SCRATCHY, WHAT HAS HAPPENED?

After you've used a nib for a while, you will start to understand the feel of it. Every nib has its own characteristic feel (do note that this will change depending on the paper you use).

When you have not changed anything about your paper, ink or writing style, and you find your nib is starting to get very scratchy, that's a sign that your nib is nearing the end of its life.

Another indicator that your nib has seen better days is when it repeatedly 'catches' on the paper, especially on upstrokes. This will usually be accompanied by very unwelcome ink splatters on your paper.

CAN I USE A NIB THAT HAS RUST ON IT?

Yes you can. However, you should probably replace it, rather than storing it with the rest of your nibs.

Rust usually occurs when your nib has been used and not cleaned properly before being put away, or it has been stored in a container with moisture. Grab some silica gel packets (you find them in new shoe boxes) and pop them into your nib container to absorb any moisture.

CAN I USE A NIB THAT HAS SPLIT TINES?

When you hold the nib up, if the tines are split and not contacting each other without pressure being applied, it's time to throw it away.

 If it's an absolute emergency, and you need a nib immediately with no other alternative, you can flip the nib face-down, and gently press it against a smooth surface to bend the tines back into position.

 However, this will only prolong the nib's life by a scant page or two.

I CAN'T DO HAIRLINE STROKES ANYMORE. WHY?

Generally speaking, one strong and defining characteristic of nibs is their ability to produce hairline strokes that no pen or pencil can.

 While you may see some flexing and variation on your downstrokes, you will generally want to achieve hairline upstrokes.

 If, on an upstroke where little to no pressure is applied, you are no longer achieving hairline strokes, that is yet another sign of a deteriorating nib.

WHY IS THE INK NOT FLOWING FROM THE NIB?

Check to see if the nib is clean. Particularly when using thicker ink (sumi/acrylic), you'll find that you need to rinse the nib more often while writing. This is because thicker inks are prone to drying up and crusting on the nib, therefore affecting ink flow. If the nib is brand new but the ink is not flowing from the nib, try preparing it again. Perhaps it wasn't prepared properly at the start and the protective lubricant is still there.

SHOULD I PRACTISE WITH GRIDLINES OR WITHOUT?

Personally, I switch between practising with gridlines and without, depending on what I am trying to achieve. Practising with gridlines helps you with uniform proportion and slant. However, if that's not your focus in your practice, then a baseline will suffice.

INDEX